The Arts at State Colleges and Universities

Joe N. Prince

American Association of State
Colleges and Universities

Material adapted from *The Rise of the Arts on the American Campus* by Jack Morrison is used by permission of The Carnegie Foundation for the Advancement of Teaching.

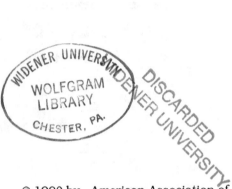
© 1990 by American Association of State
Colleges and Universities
One Dupont Circle/Suite 700
Washington, DC 20036-1192

Distributed by arrangement with:
University Publishing Associates, Inc.
4720 Boston Way, Lanham, MD 20706
3 Henrietta Streete, London WC2E 8LU England

Library of Congress Cataloging-in-Publication Data

The Arts at state colleges and universities/Joe N. Prince
 p. cm.
 ISBN 0-88044-121-6. — ISBN 0-88044-120-8 (pbk.)
 1. Arts—Study and teaching (Higher)—United States. 2. State
universities and colleges—United States—Curricula. I. Prince,
Joe N. II. American Association of State Colleges and Universities.
NX303.A727 1989
700'.71'173—dc20 89-18040
 CIP

Contents

Preface

In my 24 years as president of the American Association of State Colleges and Universities (AASCU), it has been my privilege to visit a great many member institutions. On those visits, I have been continually struck by the expansion of the arts and the ways in which they enrich their campuses, communities, and regions.

In recognition of this enrichment, AASCU has developed, over the years, an increasing commitment to the arts on behalf of its membership. A Committee on the Arts, composed of AASCU presidents, has existed for 21 years. Its projects have included a survey of the conditions of the arts on campus (1973); a national forum for educators, artists, and arts administrators (1975); a national Gallery of the Arts Week (1981); publication of "For Arts Sake," a statement on the value of the arts on campuses (1981); and, since 1987, publication of "The Arts," an insert in AASCU's weekly *MEMO: to the president.*

For the past two and one-half years, Joe Prince has served as AASCU's Senior Consultant for Arts and Humanities. A former fine arts dean at an AASCU institution and the director of the education program of the National Endowment for the Arts, he has an important overview of the arts in America that benefits AASCU and its member institutions. In addition to directing this study and writing this book, for which we are most appreciative, he writes "The Arts" for *MEMO: to the president* and serves as liaison to the Committee on the Arts. He serves as a valuable resource on the arts to this association and its member institutions. We are grateful for all of his contributions to the arts and higher education.

This study examines current conditions of the arts at state colleges and universities. It describes the great variety of programs, reflecting the variety of institutions. The central theme running through the data and the narrative confirms that which I have witnessed over the years: the arts are valued and valuable to the campus and community. They truly enrich the environment and enliven the spirit of countless individuals. Consequently, they deserve our gratitude and support.

Allan W. Ostar
President, AASCU

Foreword

The Committee on the Arts, in light of the useful information gained through a 1973 study, sought a subsequent survey on the state of the arts at AASCU institutions. With appreciation to Joe Prince, who helped secure funding to support the project, directed the study, and wrote this book, we are pleased to present this useful and comprehensive chronicle of the arts at AASCU institutions.

The book describes the state of the arts in public higher education, specifically at AASCU institutions, presents us with information that reinforces the importance of such programs, causes us to reflect on new ideas, and enables us to reaffirm our commitment to providing quality arts experiences for students, faculty, and community residents. The rich diversity of AASCU institutions—in terms of size, type, location, and socioeconomic environment—reflects America. The arts in these institutions mirror that diversity and demonstrate both the commonality and variability of the arts as campuses seek to educate artists, teachers, and scholars, and to fulfill their role as cultural centers.

Jane E. Milley
Chair, AASCU Committee on the Arts (1987-1989)
and Chancellor, North Carolina School
of the Arts, University of North Carolina (1984-1989)

Acknowledgments

I am grateful to The Ford Foundation for its support of this endeavor. Its continuing commitment to education and the arts has made a significant difference to both fields over the years. I also wish to thank the American Association of State Colleges and Universities and its staff for assistance provided me. Specifically, I wish to acknowledge the encouragement of President Allan W. Ostar and applaud his continuing support for the arts. I want to thank Allan Watson, vice president for educational resources for his help with and support of this project. Meredith Ludwig, director of the Office of Association Research and Information Resources, and Jerry Kress, research associate, are to be thanked for their assistance in data collection, compilation, and analysis. I am grateful to Joanne Erickson, director of the Office of Publications, and Trudy James, production manager, for their help in editing and producing the manuscript. My appreciation goes to Jane Milley, chair of the committee on the Arts, to the Committee, and to others who shared their perceptions and reactions to the work. Finally, I wish to thank the campus liaisons who contributed information and data that form the basis of this publication.

Joe N. Prince
Senior Consultant
for Arts and Humanities
AASCU

1

The Arts in America:
An Overview

Any examination of the arts at state colleges and universities should be placed in a broader context because public institutions are an integral part of the national fabric.

Much has been written in recent years about the state of the arts. Such agencies and organizations as the National Endowment for the Arts, the National Assembly of State Arts Agencies, the National Assembly of Local Arts Agencies, the Association of College, University, and Community Arts Administrators, the American Council on the Arts, numerous foundations, arts service organizations, and others have researched and published information and views on the topic. Such literature is useful in establishing a context for the rest of the discussion in this book.

The Ford Foundation has noted that "the arts in the United States have undergone an unprecedented expansion in the past thirty years. . . . A combination of social, economic, and cultural forces was responsible for this phenomenon: a better educated population with enlarged cultural horizons, a period of strong economic growth and prosperity, and a generation of young artists, who, while drawing from European arts forms, expressed themselves in uniquely American ways."[1]

Few would argue against the view that the arts have become a vital factor in the lives of millions of Americans. Arts growth, in all forms and places, has been phenomenal in the last three decades.

In 1960, the report from the President's Commission on National Goals, entitled *Goals for America,* noted that the popular arts in America often lacked sufficient substance and that the fine arts lacked sufficient audience. In that publication, August Heckscher noted that "an industrial civilization, brought to the highest point of development, has still to prove that it can nourish and sustain a rich cultural life. In the case of the United States, it is evident that cultural attainments have not kept pace with improvements in other fields."[2] The report goes on to say, "It has been all too natural, during epochs when a continent was being subdued or amid the fresh responsibilities of world power, to

think of the arts as something pleasant but peripheral. The time has come when we must acknowledge them to be central and conceive their fullest development as essential to the nation's moral well-being."[3]

A reinforcement of that view is detailed in a later government document.The National Endowment for the Arts, in its recent report to the President and the Congress entitled *The Arts in America,* asks, "What is it about the arts that make them central? . . . The answer is that they flow from what is central to our humanity: our ability to think and thus to reason, to feel and thus to perceive, to use all of our faculties, finally, to imagine. It is through art that we impose order on the world around us, that we share our sense of the way things are—or the way things ought be—with others, that we communicate our ideas across all the boundaries—national, political, racial, social—that so often frustrate other means of discourse."[4] Therefore, as a result of education, public and private support, and a growing cultural, indeed multicultural, awareness, America today offers a flourishing environment for the arts. For example, "today more than 400 professional resident theater companies operate from coast to coast, outstripping the commercial sector as a source of employment for actors. More than 250 professional dance companies exist across the nation and many of them tour to cities outside their states. Professional opera companies now total 110, with scores of other, smaller semiprofessional troupes. There are today over 300 principal art museums and another 300 museums that either have art collections or present art. There are over 300 visual artists' spaces (originally alternatives to commercial galleries and museums) and 105 media arts centers providing space, facilities, and equipment for the arts of the new technologies of film, television, and radio.

In recognition of the importance of the work carried out by our not-for-profit arts institutions—work that could never be sustained by the free market alone—private support has flowed steadily and increasingly into this sector."[5]

An examination of some of the various arts disciplines and arts constituents helps in developing the best perspective on the arts in America. The National Endowment for the Arts has, since 1984, annually updated a five-year planning document containing information and data based on the views and research of program officers, staff, peer panels, and the broader arts constituency. As such, it constitutes one of the more comprehensive and thorough documents available.

The following information about the various arts disciplines is derived primarily from the *Five-Year Planning Document*[6] and *The Arts in America.*[7]

American *dance* is eclectic, diverse, and intensely creative. There is a critical need for more extensive performance opportunities. Time, resources, and space to develop new works and maintain high performance standards are increasingly difficult to acquire. The problem of the high turnover rate of artistic management is compounded by the inadequate salaries and employment terms of dancers (e.g., $13,000, 35 weeks). Nevertheless, many companies are extending their seasons, several are exploring second-home affiliations, domestic touring is increasing in spite of difficulties, budgets are growing, and the field continues to view television as a key means of enhancing appreciation of dance.

Design, in its various forms, has witnessed an important growth in public awareness. The field of design encompasses architecture, landscape architecture, urban design, historic preservation, planning, and interior, industrial, graphic, and fashion design. Designers and architects number over 616,000, and this figure is expected to increase. With a larger and better-educated population, the number of clients for designers of all types is expected to grow. Even so, good design is undervalued. Haphazard growth and development continue to be major design problems for cities and suburbs.

Literature is an individually based art form. Creative writers are scattered throughout the country and work for the most part in semi-isolation. American writing encompasses enormous

breadth and diversity, enhanced by the increasing encouragement of writing at every level of this nation's educational system. Creative writing classes are found in most schools, colleges, and universities, creating more academic opportunities for writers while at the same time increasing the number of applicants for writing jobs. Literary centers, workshops, and seminars abound. Even so, except for the few authors who produce best-sellers by means of major publishers, most writers make little money from their writing. Therefore, support for writers and for small presses is still needed for continued growth in the field.

The fields of *media* (film, radio, television, recordings) are increasingly moving in the direction of the independent artist/ producer. New technologies such as videocassette and cable favor the independent artist. The network monopolies continue to decline. The network audience is now down to 69 percent. The three major areas of network programming—entertainment, sports, news—have all felt the competition of cable (which reaches over 40 million households) and cassettes (with 63 percent of all television households owning a VCR). The number of film productions continues to increase and revenues are up, thanks in part to the independent film makers and markets. Nonprofit radio is also growing rapidly. The renaissance in radio shows no signs of diminishing, and public radio is approaching its goal of reaching every locality in the country. The advent of audio compact discs (CDs), the emerging compact disc interactive (CD-I), digital audio tape (DAT), and high-definition television (HDTV) have substantial implications for audiences, equipment manufacturers, recording companies, and artists. However, media as art form continue to be expensive: the commercial market grows increasingly costly, and the nonprofit arena is increasingly dependent on contributed support.

Music flourishes in today's era of pluralism, more diverse than any other time in history. Music is being written and performed in every genre and style. The number of musical performances is increasing, with more American music as part of

those programs. The audience for classical music and jazz is substantial: over 17 million adults attended jazz performances in 1985 and over 22 million adults attended classical music performances (according to the "Survey of Public Participation in the Arts," sponsored by the Endowment and conducted by the U.S. Census Bureau in 1982 and 1985). Nevertheless, financial resources for large musical organizations, for touring, and for new music creations and presentations continue to be scarce. Large opera companies grow larger and more numerous; musical theater production is realizing an increasing trend from the commercial to the nonprofit sector. Commercial music, in the forms of rock, gospel, country and western, and the like, is "big business," with substantial risks but substantial rewards for the successful.

In recent years, the network of nonprofit *theater* companies has been preoccupied with such concerns as management, marketing, fund raising, board development, and financial stability. The major task of this network is to transcend such administrative struggles through a continuing, stronger commitment to artistry and quality. It appears that, while administrative concerns continue to be significant, artistic priorities have once again become a leading focus. Major theaters across the country prosper with adventurous and demanding work, at home and on tour. For the first time in two decades, the nonprofit theater engages more artists than all forms of commercial theater. Even so, most actors earn only $350-$400 a week for jobs lasting eight weeks or less. Such budgetary issues as higher and higher rent for rehearsal and performance space in major cities continue. More theaters are beginning endowment funds, but, to date, they cover only 1-2 percent of these institutions' expenses.

The *visual arts* field is large and diverse, comprising thousands of artists working in a variety of styles and media: painting, sculpture, printmaking, crafts, photography, and new genres. In the next few years, the demographics of the artist population will change, and the needs of more midcareer artists, whose work is

reaching maturity, will affect organizations that form the support structure for visual artists: artist-run spaces, contemporary art museums, university art departments and galleries, commercial galleries and private collectors, and funding sources. Visual artists need time to create; this translates to direct support by public and private organizations and individuals. Finally, public art continues to be a vital and lively topic to artists, laypersons, and local governments and businesses.

Arts education holds the future of many artists and audiences in its grasp. Arts education must provide all students with knowledge of, and skills in, the arts. It "must give students the essence of civilization, the civilizations which have contributed to ours, and the more distant civilizations which enrich world civilization as a whole. It must also give students tools for creating, for communicating and understanding others' communications, and for making informed and critical choices."[8] An extensive discourse on arts education is found in the referenced report to Congress from the National Endowment for the Arts. It builds on and agrees with numerous earlier studies on arts education, including *A Nation Prepared: Teachers for the 21st Century* by the Carnegie Task Force on Teaching as a Profession; *Time for Results: The Governors' 1991 Report on Education,* by the National Governors' Association; *First Lessons: A Report on Elementary Education in America* of the U.S. Department of Education; *Beyond Creating: The Place for Arts in America's Schools,* by the Getty Center for Education in the Arts; and *Arts, Education and the States,* by the Council of Chief State School Officers with support from the National Endowment for the Arts, the U.S. Department of Education, and the Rockefeller Foundation.

In the current move for educational reform, the arts have made some progress. Some 29 states have enacted high school graduation requirements that in some way include the arts, and 42 states require school districts to offer arts instruction in public schools. However, few elementary school teachers are prepared

for the task of teaching the arts, the curricular offerings are seldom sequential, and the content is often spotty. So, while there is substantial public and professional attention given to arts education in the nation's elementary and secondary schools, and there are numerous examples of quality teaching and learning, the Arts Endowment's report states: "To sum up, the arts are in triple jeopardy: they are not viewed as serious; knowledge itself is not viewed as a prime educational objective; and those who determine school curricula do not agree on what arts education is."[9] The interested reader is urged to examine the myriad information in that comprehensive publication.

An examination of the state of the arts in the nation should include certain issues that transcend specific arts disciplines.

The individual *artist* is the foundation for all art. All aspects of the arts world depend on the individual. Therefore, crucial to the future of the artist, and thus the arts, is artistic training. Although the record of elementary and secondary school arts education is spotty, higher-level artist training appears to be flourishing. Through higher education or master-apprentice collaborations, excellent training opportunities appear to be available. The chief problem for artists appears to be insufficient salaries and job opportunities after completion of their training. For example, there are more musicians in training than professional spaces available, dancers have brief, poorly compensated careers, actors face low compensation and severe competition, and other arts professions involve similar obstacles. Nevertheless, young artists are exploring new mechanisms for producing their arts, the field still attracts people, and most would not trade their vocation for any other. The same creative spirit that pervades their art production pervades their lives and allows compensations and adjustments.

Audiences continue to grow. Virtually every American is touched by some kind of art every day, either directly or indirectly, overtly or covertly. However, much of this contact is with popular art and is casual. The 1982 and 1985 Surveys of Public Partici-

pation in the Arts show that between 10 and 20 percent of adults had attended jazz, classical music, opera, musical theater, theater, or ballet performances or visited art museums or galleries. With the growth of touring and presenting of arts events, the development of community-based arts centers, and the outreach efforts of arts organizations and institutions and higher education institutions, this audience is expected to grow. Education is the key to increasing this participation. The survey found that education is the primary determinant of attendance at arts events and, unlike such factors as geography, occupation, and income, is subject to a degree of external influence. A second encouraging survey finding is that nearly one-third of the "non-attenders" indicated a desire to become involved in arts events in the future. Although the media have played a significant role for promoting the arts to the populace, there is potential for increasing the active, live audience.

An examination of the status of the arts in America today reveals an increasing cultural and multicultural diversity. Both artists and audiences reflect the various cultures and populations of this nation. This increasing reflection of the arts of Blacks, Hispanics, Asians, Africans, Native Americans, and others greatly enriches the artistic atmosphere. The folk arts and crafts from around the United States and the world are now a part of the American arts world. Community-based arts centers reflect and encourage wide diversity. The multicultural arts have become a part of increasing cultural pride while, at the same time, enriching and extending the arts world. America is richer for this expansion.

Finally, no review of the status of the arts in the nation would be complete without recognition of the role of government (local, state, and federal), the private-sector foundations and corporations, and the individual philanthropist. Government support for the arts has been an important symbolic and catalytic influence. It has not only enhanced the "established" arts but has also created an atmosphere in which the arts can flourish and grow in

unique, nontraditional ways. Few would dispute the historical value of National Endowment for the Arts' efforts to help the arts flourish. State arts councils have likewise been a significant influence. Indeed, the aggregate state appropriations for the arts now exceed federal support. At the same time, local arts councils have grown and prospered and have provided the necessary grass-roots support for strengthening the national fabric of the arts. Corporate and individual charitable contributions to support the arts have similarly increased. According to the American Association of Fund-Raising Counsel, "From 1970 to 1987, contributions to the nation's cultural organizations from individuals, foundations, and corporations have grown nearly ten-fold, from $660 million to $6.41 billion."[10]

Notes

[1]Office of Reports, Ford Foundation, *Ford Foundation Support for the Arts in the United States* (New York, 1986), p. 3.

[2]Presidential Commission on National Goals, *Goals for Americans* (Englewood Cliffs, NJ, Prentice-Hall, 1960), p. 127.

[3]*Goals for Americans, p. 145.*

[4]*The Arts in America: A Report to the President and the Congress,* (Washington, DC: National Endowment for the Arts, 1988), pp. 4-5.

[5]*The Arts in America,* p. 3.

[6]*Five-Year Planning Document: 1990-1994,* (Washington, DC: National Endowment for the Arts, 1988).

[7]*The Arts in America.*

[8]*Toward Civilization: A Report on Arts Education* (Washington, DC: National Endowment for the Arts, 1988), p. 13.

[9]*Toward Civilization,* p. 19.

[10]*The Arts in America,* p. 3.

2

The Arts in Public Higher Education:
An Overview

Although the National Endowment for the Arts publications, which draw heavily on existing data and information, new research, and expert opinion, present a wealth of information of the arts in America, they do not fully reflect the status of the arts in higher education and their subsequent influence on the arts in general across this nation. There is a considerable body of respected and published opinion contending that colleges and universities not only educate future artists, teachers, and audiences but also provide professional opportunities and support for artist/teachers, promote artistic experimentation and creation, serve as repositories of knowledge about the arts, and are the cultural centers for their geographic regions.

Training Artists and Teachers of Art

In 1986, the Working Group on the Arts in Higher Education noted that "higher education is the place where both professional artists and professional teachers of the various arts receive advanced education and training."[1] Higher education today educates, each year, nearly 125,000 artists (in visual arts, music, dance, and theater) and teachers of art (in those same four disciplines). Public higher education institutions enroll some 72 percent of those students.[2] Although conservatories and private schools still have an important place in the development of artists and teachers, the number of arts students pursuing a college or university education is increasing. This trend has resulted from several factors, including increasing enrollments in public higher education in general, expansion and improvement of arts and arts education curricula, vastly improved facilities and equipment on campuses, the increase in talented faculty artists/teachers/scholars at colleges and universities, improved articulation between colleges and universities and secondary schools, and the comparatively lower costs of public higher education.

"The education and training of professionals in dance, music, the visual arts, or theatre involve a fusion of intellectual, emotional, and physical capabilities based in practice in the specific discipline. This task requires significant time in the discipline itself. Yet, the well prepared artist also must be liberally educated. Thus, education programs for artists aim to prepare individuals who understand the cultural and aesthetic significance of the art they practice. Such comprehensive understanding with attendant skills, attitudes, and aptitudes is the fundamental ingredient in a liberal education as traditionally conceived."[3] This philosophy undergirds college and university programs for professional artists.

Public colleges and universities provide students with the opportunity to grow artistically, intellectually, and personally. Institutions enact departmental and programmatic admissions and retention standards to help ensure quality while taking care to apply them in a manner that preserves the students' incentive to succeed. Graduation requirements, usually quite rigorous, result in young professional artists who are talented, trained, and broadly educated, thus helping to ensure their professional success.

Colleges and universities have a particular mission in the development of teachers of the arts. In recent history, most arts teachers have been educated in colleges and universities, the majority in public institutions.[4] These individuals usually have undergone academic programs that included artistic development, liberal arts education, and the development of teaching skills. Graduates of arts teaching programs are expected to have "(1) a basic knowledge of the aesthetics of the discipline; (2) a basic knowledge of studio art (or music, or drama, or dance performance); (3) a basic knowledge of the history of the art form; (4) a basic knowledge of criticism; and, (5) some knowledge of the art disciplines outside the discipline of the major."[5] General elementary classroom teachers are another group of teachers who have received their education in colleges and universities.

Their arts training, unfortunately, has usually been meager and inadequate to ensure their comfort and success with the arts in the classroom. To their credit, some institutions of higher education are realizing this deficiency, are making curricular changes, and are initiating inservice programs to help remedy the situation.

Public higher education institutions have also made signicant strides in graduate programs and in lifelong learning opportunities. Both of these movements have expanded the pool and improved the quality of artists and teachers.

Educating Audiences

With vast numbers of students arriving on their campuses whose only exposure to the arts is rather cursory (and often related only to the popular arts), colleges and universities have begun, over the years, to reexamine their roles in educating the general college student—in light of fostering informed and sensitive individuals and audiences of tomorrow. As early as the 1960s, higher education, not the arts community, was discussing these issues. In an early study, Mahoney noted, "Education must provide all students with some capacity for sensual perception and expression, with an understanding of the necessary interplay of perception and expression. The judgment of human creations obviously requires the ability to perceive different options. The student needs to know what the past can provide in the way of models of perception, and he will need to experiment with ways to perceive and ways to integrate his own perceptions. To the extent that he is aware of the continuity of his mode of seeing (or hearing, or touching, or reading) with that of other men, he will have a sense of rootedness in a tradition which he can accept as his own."[6] However, Mahoney goes on to note that despite the growth of college arts programs, there was no concomitant growth in substantive programs for the general student. "The discrepancy between the growth in commitment to the arts and the

exclusion of arts courses from the required curriculum suggests that while college are giving students more opportunity for artistic experience than ever before, many have not thought through the objectives of their arts programs."[7] At nearly the same time, a publication of the American Association for Higher Education, a department of the National Education Association, noted that "colleges and universities appear intent on building sensitive, mature, and intelligent audiences and are having an increasingly greater effect on the status of the arts. This participation places them in a position to control both kind and quality."[8]

Colleges and universities frequently took these challenges seriously and increased and improved their offerings for the general student. Participation, where present, has taken the forms of introductory courses, public performances, exhibitions, films, and the like, in both formal and informal settings. According to data developed by the National Association of Schools of Music and the College Music Society, "public four-year institutions have the most comprehensive music appreciation programs...and operate the largest number of class sections." The report goes on to note that, in the fall of 1981, "more than 50,000...students were enrolled [in music appreciation courses] at four-year institutions."[9] Yet, as late as 1985, Morrison felt compelled to note that "more members of our society than ever will need something to do to make life worth living. Higher education in the arts can help provide meaningful activity for our people by educating and training skilled amateurs."[10] Thus, it appears that the need for educating the general student is recognized; program issues seem less clear but are continuing to emerge.

Support for the Professional Artist

The growth in university arts programs over the decades has given professional artists an important role in academe. The traditional dichotomy of professional-versus-teacher is dimin-

ished in the arts as in few other disciplines, but this was not always so. As late as 1968, the profession was still exploring the matter. In discussing visiting artists, one study noted, "What can [the artist and the university] contribute to the other? If arrangements between artist and university are primarily economic—that is, so many dollars for so many musical compositions or paintings—the project will undoubtedly not succeed. Such a project will attract the wrong kind of artist—the hungry and the exploitable. The university must provide an enhancing environment that will nourish and encourage the artist's professional development and his professional career. In return, the artist's presence must augment and enrich the university's resources and climate, steadily offering contributions outside of regular curricular patterns."[11] It appears that more recent perceptions, while in agreement, have diminished the dichotomy by establishing the campus as a home, through agreements similar to that above, for individuals who are both artists and teachers—truly professional as both.

Experimentation and Creativity

College and university campuses have traditionally been centers of thought, exploration, experimentation, and research. As arts programs developed on campuses, creativity was added to that essential list. It has been noted that "the university provides the culture in which new ideas, new talents, and new art forms can flourish" and that it is "ideally suited to expose its students to new music, new theater, new art, and new dance." This source notes that "supported research in the arts is in its infancy. Art historians, musicologists, and art educators have in their separate ways engaged in types of scholarly research. Much of it has been poorly supported, if at all, and much of it is carried out in the researcher's own time."[12] Morrison, in his writings of about the same time, notes the necessity for and value of R&D.[13] According to "The Core of Academe," "creative endeavor refers to

the result of the production of creative work by faculty. Creative endeavor is most easily identified when associated with the performing arts (theatre, music, dance) and with the fine arts (two- and three-dimensional art, writing). It is also most appropriate to apply it in the area of applied arts (architecture, graphics and printing, design, decorating). Creative endeavor involves not only the creation of a tangible product, but the subjection of that creative piece to judgment by public and peers through the vehicle of performance, show, publication, display or exhibit."[14] But Morrison cautions, "The work for the artist cannot be understood on terms other than his own. There is a need for an understandable analog to the work of scholars and scientists if the artist is going to be an integral part of the academic scene. There still prevails a notion on the part of many scholars that the artists are 'Mickey Mice,' who merely play at fun and games. And, if the discursive symbols of the scholars—words and numbers— are the sole measure of the artist's work, they do come off as Mickey Mice. But if non-discursive symbols—color, line, sound, beat, moving bodies and moving images—are used as additional ways of knowing, the artists' work comes off as very serious, as 'import' laden with values on its own 'scholarly' terms."[15]

Campuses as Cultural Centers

Glenn T. Seaborg, former chairman of the U.S. Atomic Energy Commission, appeared before the Senate Special Subcommittee on the Arts and Humanities to note an imbalance in the nation's priorities. As a scientist, Dr. Seaborg called for support of programs in the arts and humanities, especially those aspects constituting values. Such disciplines as music, dance, and art all hold values that are ends in themselves and at the same time offer rewards in terms of an individual's pursuit of happiness. He urged that attention be given to leisure time, stressing that the spiritual, physical, and mental well-being of the nation's population is essential. As leisure time increases, few are

prepared for it.[16] As many have noted, the campus, as cultural center, can have an important role in the formal and informal educative process. The 1985 Morrison study notes that "often, if not always, the campus is the cultural center for the community for off-campus arts events as well as those developed on campus. Galleries, concert halls and theaters for exhibits, concerts and shows are often the only exhibit and performing spaces available."[17] And nonacademic sources such as the *New York Times*, in an April 1988 piece headlined "Performing Arts on College Stages: High Quality at Low Prices,"[18] extolled the virtues of campuses as cultural centers. Campus press releases show that colleges are working with communities to enrich the cultural atmosphere for citizens.

Brief History of the Arts Disciplines on Campus

As noted earlier, an excellent study of the arts on campus was completed by Jack Morrison in 1973 for the Carnegie Commission on Higher Education. In it, Morrison detailed a brief but thorough history of the various arts disciplines on the campus. In 1985, he updated the earlier work. (In order to put subsequent chapters of this publication in perspective, and in a hope that the interested reader will examine Morrison's historical descriptions more closely, this author extrapolates liberally from *The Rise of the Arts on the American Campus*[19] and *The Maturing of the Arts on the American Campus: A Commentary*.[20] All other sources are identified separately).

Opinions about *dance* as a part of society were divided in early American history. Certain types of dancing were permitted and thus became a part of education. This trend grew steadily through the eighteenth century but was followed by a movement in the nineteenth century, among education and church leaders, to keep dancing off the campus. Even though this view kept dance out of many colleges and universities throughout the nineteenth century, in some places (e.g., Harvard, University of Virginia,

William and Mary) it was encouraged and developed. Dance began to appear as a form of exercise in private schools. The debate continued until 1926, when the University of Wisconsin offered a program of dance as an art experience rather than a program of recreational or "genteel" social exercises. By 1948, some 105 colleges and universities offered dance and 92 gave academic credit for it. Dance programs continued to grow and to be located in dance, theater, fine arts, and physical education departments. In 1962, New York University offered the first Ph.D. for choreography as a performing art; the "dissertation" was presented in concert form. As the newest of the arts on campus, dance has been less subject than others to academic partitioning and territorial issues, thus allowing a focus on its development as a rigorous art form. Between 1973 and 1985, college dance programs more than doubled and witnessed growth in the areas of performance, choreography, and criticism. In numerous instances, growth was enhanced by closer relationships between educational institutions and professional companies. Recent data on dance education come from the Higher Education Arts Data Services (HEADS). The 51 colleges and universities, most of which are members of the National Association of Schools of Dance, reported a dance major enrollment of 2,159 for the fall of 1986. These students were taught by 191 teachers who were supported by average budgets of $263,487.[21]

A course in *architecture* principles and history was offered at the University of Virginia until the Civil War. Before the Civil War, architects were trained in Europe; training in the United States was conducted through apprenticeships. In 1865, the Massachusetts Institute of Technology offered a professional course in architecture. Programs grew steadily, so that academic programs grew from nine schools in 1898 to 53 in 1930. The American Institute of Architects was founded in 1857 and immediately established an education committee. Through its efforts, the profession encouraged the development of programs and established professional standards to enhance those programs. In the

early years of the twentieth century, a compelling interest in *design*, in addition to issues of construction and economics, developed on campuses. This development, resulting in design competitions, began to dominate methods and objectives of design teaching. Thus, from the beginning, architecture in higher education was faced with the issue of integrating the various components of the discipline into balanced educational programs. Programs continued to grow through the twentieth century (except during the Depression) and continued to wrestle with the balance of the aesthetic, construction capabilities, and economic concerns.

Writing and the study of literature have always been a part of instruction in English. Over time, special classes evolved in various schools in the area of *creative writing*, designed to encourage imagination, expression, and literary skills. At the same time, there was a growing awareness of creative writing as an art form. Not until the 1960s, however, was there much formal effort to identify university writing programs with other arts. In 1968, the College English Association published a directory of creative writing programs within English departments on campuses; some 680 were identified. By 1970, 37 institutions offered an undergraduate major or concentration in creative writing, 58 offered graduate program at the master's level, and four offered doctoral programs. By the mid-1980s, nearly all colleges and universities offered courses in creative writing. There has also been an accompanying growth of writers-in-residence and university presses, both of which enhance the campus and the profession.

Media (film, video, radio) as a discipline began in the university as film courses, usually the "introductions to motion pictures" variety, in the 1920s. For the first 50 years, this type of course remained the most widespread. The first major in film was offered in 1932 by the University of Southern California, which subsequently offered a master's in cinema in 1935 and one of the first doctoral programs in film-related work, all in a communica-

tions framework. However, expansion in film studies did not begin until after World War II, with the major growth occurring in the 1960s. From 1959 to 1971, degree programs in film grew from 10 to 47. Most film programs are part of a larger unit, usually broadcasting/communications or theater. Film courses tend to fall into four major categories: appreciation/history/introduction, elementary production, professional production, and scholarly study. A problem with film production and scholarly curricula is *cost:* films, equipment, and materials are expensive. In the past decade, technological advancements (VCR, tape, discs, satellite transmission), economic changes (cable, videocassette), and social pressures (airway ownership, access) have emerged as factors in all media programs. More and more, motion picture and television, once distinct disciplines, are interrelated. Additionally, films and video are viewed by other departments as documenting society, and thus media departments work more closely with sociology, history, and ecology departments on a campus.

From the Middle Ages to the present, the locus for *music* has shifted from the church, to the aristocracy, to the conservatory, to the university. As one subject of the quadrivium, music as a degree program was offered at Cambridge in 1463 and Oxford in 1499. Evidence indicates that music was a part of Harvard's curriculum as early as 1698. By 1800, the community singing societies and music clubs shifted to campuses and were a regular part of college life. Yet it was not until the middle of the nineteenth century that music developed as an appropriate instructional subject in higher education, first in vocal music with an emphasis on preparing students to teach. Beginning with normal schools in the Northeast, music in higher education grew as Oberlin College established a professorship in sacred music in 1835 and established the Conservatory in 1865. Harvard and Vassar offered courses in the 1860s. After Oberlin Conservatory's establishment, the conservatory movement grew rapidly and substantively. By 1915, music was an accepted academic discipline in

colleges and universities throughout the United States, with programs in performance, history, and education. The Depression of the Thirties took its toll of all but the strongest (either musically or economically) conservatories, while college and university programs continued to grow. A great disparity in quality of programs led to the formation of the National Association of Schools of Music in 1927, which resulted in definable standards and national norms. University music programs continue to offer courses in performance, history, composition, education, and general education. The Fall 1986 data in the Higher Education Arts Data Services (HEADS) were provided by members of the National Association of Schools of Music and a few other volunteer institutions. The 411 institutions in the survey reported total enrollments of 54,482 music majors, with 8,287 master's degree students and 2,419 doctoral students. The institutions' music programs were staffed by 6,359 faculty members and supported with an average budget $851,426.[22]

Theater was present at Harvard at the end of the seventeenth century. Drama appeared in the forms of "academic exercises," extracurricular activities, and playwriting by faculty and students for commencements and other events. In 1844, the Hasty Pudding Club was formed and served as a model for extracurricular dramatics in other colleges and universities throughout the country. Professional companies and individuals were brought to campuses for performances and lectures. Through World War II, drama instruction was usually offered through speech courses, although a few drama departments began to emerge. By the middle of the twentieth century, theater in colleges and universities was established on its own terms. The number of departments, curricula, and students rose rapidly. Between 1960 and 1967, the number of undergraduate majors tripled. This growth was followed by efforts to raise the standards of the field and to "professionalize" programs, including establishing professional standards and establishing relationships between training institutions and professional theaters. Additionally, the term *theater*

began to be defined more broadly to include children's theater, "street theater," and other forms. Thus, theater on campus moved from a liberal-arts, avocational base toward professional training and toward improving theater education for elementary and secondary schools. In the 1960s and 1970s, there were five principal developments: (a) theater degree-granting programs proliferated; (b) performing arts high schools received the imprimatur of the education and theater professions; (c) the Master of Fine Arts became widely accepted as the terminal degree in performance; (d) Doctor of Philosophy degree programs lagged in popularity behind the M.F.A.; and (e) professional theaters and guest artist programs became part of training programs. HEADS received reports for the fall of 1986 from 104 educational institutions, most of which were members of the National Association of Schools of Theatre. These institutions reported total major enrollments of 10,091, with 1,479 enrollments at the master's level and 119 at the doctoral level. The departments of these 104 institutions were staffed by 1,487 faculty members and expended an average of $460,699.[23]

The *visual arts* are thoroughly entrenched in higher education. Although there are numerous excellent independent professional art schools, colleges and universities are the major educators of artists. The first formal program in the visual arts was established at the Pennsylvania Academy of the Fine Arts in 1806. Other schools of art soon followed, all functioning primarily as centers for preparing painters and sculptors. But Syracuse, Yale, Illinois, and a few other institutions viewed the practice of the arts as having humanistic values compatible with other university pursuits. Arts programs in colleges grew rapidly after 1900. The independent schools were freer in their curricula, structure, and faculty roles—much as with the European model. Universities, on the other hand, and of necessity, subjected art students to the overall requirements, structure, and style of the all university programs. As state departments of education tightened teacher certification requirements in the 1930s, some independent schools,

which had teacher education programs, moved to seek accreditation. This often resulted in affiliation with a college or university. The Bachelor of Fine Arts was established as a respectable degree.

After World War II, college-based programs grew rapidly with the combination of studio and liberal arts curricula. In the assimilation of the studio concept into the university mold, many instances of give-and-take were essential. In addition to preparing artists, university programs have been developed and improved to prepare teachers of art and to enlighten the general university students who will become the art "consumers" of tomorrow. As an indication of the current magnitude of the visual arts in higher education, an examination of the 1986 HEADS report reveals that 159 institutions reported total art and design major enrollments of 58,221, with 4,557 at the master's level and 222 at the doctoral level. These institutions, most of which are members of the National Association of Schools of Art and Design, employ 3,043 faculty members and support the art and design programs with average budgets of $1,557,198.[24]

Notes

[1]Working Group on the Arts in Higher Education, *The Structure of the Arts in the United States: Current Conditions and Next Steps from the Perspective of Higher Education* (Reston, VA, 1986), p. 22.

[2]Data Summary 1986-87, Higher Education Arts Data Services (HEADS) (Reston, VA, 1987).

[3]Working Group on the Arts in Higher Education, *The Arts, Liberal Education, and the Undergraduate Curriculum* (Reston, VA, 1985), p. 10.

[4]HEADS.

[5]Kathryn A. Martin, "On Teaching Arts Teachers to Teach," *Teachers in the Arts: A National Symposium* (Baton Rouge, LA: Louisiana State University, 1985), p. 27.

[6]Margaret Mahoney, ed., *The Arts on Campus: The Necessity for Change* (Greenwich, CT: New York Graphic Society, Ltd., 1970), p. 37.

[7]Mahoney, pp. 127-28.

[8]Lawrence E. Dennis and Renate M. Jacob, eds., *The Arts in Higher Education* (San Francisco: Jossey-Bass, 1968), p. 76.

[9]National Association of Schools of Music and College Music Society, *Music in General Studies: A Survey of National Practice in Higher Education* (Reston, VA, 1968), p. 3.

[10]Jack Morrison, *The Maturing of the Arts on the American Campus: A Commentary* (Lanham, MD: University Press of America, 1985), p. 107.

[11]Dennis and Jacob, pp. 72-73.

[12]Dennis and Jacob, pp. 76-77.

[13]Jack Morrison, *The Rise of the Arts on the American Campus* (New York: McGraw-Hill Book Company, 1973), p. 166.

[14]"The Core of Academe: Teaching, Scholarly Activity, and Research" (Washington, DC: American Association of State Colleges and Universities, 1987).

[15]Morrison (1985), pp. 104-105.

[16]National Arts and Humanities Foundations, Hearings Before the Special Subcommittee on Arts and Humanities of the Committee on Labor and Public Welfare, United States Senate, Eighty-Ninth Congress, February 25, 26; March 4, 5, 1965. Part II, pp. 404-407.

[17]Morrison (1985), p. 101.

[18]Andrew L. Yarrow, *New York Times*, 15 April 1988, p. C1.

[19]Morrison (1973), pp. 7-37.

[20]Morrison (1985), pp. 7-69.

[21]HEADS.

[22]HEADS.

[23]HEADS.

[24]HEADS.

3

The Arts at AASCU Institutions

The following study was designed to examine the arts at member institutions of the American Association of State Colleges and Universities (AASCU). This examination was intended to result in a current picture of the condition of the arts on campuses; reinforce programs and perceptions; raise new issues to ponder; and hopefully be useful to others who might be building, expanding, or improving programs. A survey instrument seeking both data and information was mailed to the member institutions in an effort to discover conditions and trends. A total of 215 respondents provided the data and information from fall 1987 statistics.

A list of the respondent institutions, which vary greatly in scope, size, and mission, appears in the appendix of this publication. An analysis of the responses provides a useful picture of the arts at state colleges and universities.

General Information

Administrative Structure of the Arts on Campuses

Adminstratively, the arts programs at state colleges and universities are housed in a wide variety of settings. This is not surprising when one considers the range in size, scope, and mission of the institutions. Some 16 percent of the respondent institutions have colleges or schools of the arts (fine arts and/or performing arts). Another 12 percent are located in colleges or schools of arts and humanities/letters. A relatively high number, 23 percent, place the arts in colleges or schools of arts and sciences. Only 3 percent have colleges or schools of arts and communications. The balance of respondents are located in other kinds of entities or reported as single departments.

Arts Faculty/Staff

According to 88 percent of the respondents, there are 10,062 full- and part-time faculty members working in the arts. The numbers,[1] by arts disciplines, are noted in Table 1.

Table 1: Number of Faculty by Arts Discipline

Arts Discipline	*Number*
Art	3,092
Music	4,272
Dance	352
Theater	1,126
Film	79
Radio/Television	411
Arts Education	183
Interdisciplinary	86
Other	461
Total	10,062

Not surprisingly, the largest number of faculty are found in music (42 percent of the total), art (31 percent), and theater (11 percent). These departments have been on most campuses longer, historically have been larger than other arts faculties, and are by their nature labor intensive.

When asked to compare the size of arts faculty/staff as a percent of the university staff with that of five years earlier, 40 percent of the respondents indicate that the percentage for arts staff remained stable, and 34 percent report an increase. Twenty-four percent state that the arts faculty/staff as a percent of the total university declined in the last five years.

Male and Female, Full- and Part-Time Arts Faculty Members
The percentages of full-time male and female and part-time male and female faculty members, by discipline, are found in Table 2.

Table 2: Faculty by Arts Discipline, Sex, and Employment Pattern

Discipline	Male Full-Time	Female Full-Time	Male Part-Time	Female Part-Time
Art	53%	21%	12%	14%
Music	53	15	18	13
Dance	17	47	9	27
Theater	58	22	9	11
Film	47	32	15	6
Radio/Television	59	16	17	8
Arts Education	48	38	5	9
Interdisciplinary	41	31	10	17
Other	44	24	19	14
All Arts	52	20	15	13

Apparently, with the exception of dance, the arts faculties are predominantly male. When compared with the faculty of five years earlier, however, the trend appears to be running in the opposite direction. Some 50 percent of the respondents note that the full-time female faculty has increased, 32 percent indicate stable conditions, and only 18 percent note a decline in the full-time female faculty. At the same time, only 28 percent note an increase in full-time male faculty, 35 percent note stable conditions, and 37 percent indicate a decrease in full-time male faculty. The patterns for part-time female faculty follow those of full-time female faculty. Part-time male faculty are primarily either increasing or stable. Another point worth noting is the fairly high percentage (when compared with some other segments of a university faculty) of part-time faculty in the arts.

Minority Arts Faculty Members

Of special interest to this study is the extent to which

minorities are represented in the teaching and creating faculties of the respondents.

Responding institutions report a total of 426 full-time and 155 part-time faculty members from minority populations. Those individuals constitute 6 percent of the full-time male arts faculty and 7 percent of the full-time female arts faculty. They also represent 7 percent of the part-time male arts faculty members and 4 percent of the part-time female arts faculty members. The number of minority faculty members by arts discipline and the percentage they represent of their category of the total arts faculty are noted in Table 3.

Table 3: Minority Faculty by Number and Percent of Category Total by Arts Discipline, Sex, and Employment Pattern

Discipline	Male/F-T Category	Female/F-T Category	Male/P-T Category	Female/P-T Category
Art	104 (6%)	43 (7%)	31 (8%)	16 (4%)
Music	117 (5)	33 (5)	30 (4)	15 (3)
Dance	5 (8)	10 (6)	8 (27)	4 (4)
Theater	22 (3)	14 (6)	9 (9)	5 (4)
Film	1 (3)	1 (4)	0 (0)	0 (0)
Radio/Television	21 (9)	8 (13)	9 (13)	4 (13)
Arts Education	2 (2)	2 (3)	2 (20)	1 (6)
Interdisciplinary	0 (0)	0 (0)	0 (0)	0 (0)
Other	21 (11)	21 (20)	11 (13)	10 (16)
All Arts	293 (6)	133 (7)	100 (7)	55 (4)

Male, full-time, minority faculty members, as a percent of the discipline, have greater representation in art, dance, and radio/television. A greater percentage of full-time female faculty members are found in art, dance, theater, and radio/television.

Few minority faculty members are reported in film or arts education.

Surveyed institutions were asked about changes in the composition of their faculty since 1982. The majority indicate that there has been no change in the number of full-time minority male faculty (62 percent of the institutions) or full-time minority female faculty (76 percent of the institutions). At the same time, some 30 percent report an increase in full-time minority male faculty members and 16 percent in full-time minority female faculty members. Only 8 percent report a decrease in full-time minority faculty. The same general patterns are reported for all part-time minority arts faculty members, but the percentages of stable faculties are higher (82 percent), the percentages for increased minority faculty are smaller (19 percent), and the percentages for decreases are similar (8 percent).

In addition to seeking statistical information about the arts faculty, the survey included questions attempting to elicit some additional descriptive information. These narrative responses were analyzed and, wherever possible, some generalizations were drawn. As might be expected, the responding institutions varied greatly in the kind, amount, and quality of information provided. Nevertheless, useful information and patterns emerged.

Faculty Development

Most institutions have programs for general faculty development; they usually consist of several elements. The most common are sabbaticals (summer, semester, and year-long), funds for travel and workshops, and research funds (including artistic, creative research). The arts faculty are eligible to participate in these campuswide competitive endeavors and often do so, successfully. Fewer respondents note speci... faculty development programs specifically for the arts faculty. However, of those who do, released time for performing and creative endeavors is a common element. This might include course

reduction, use of on-campus facilities, and/or careful block scheduling. Though not reported often, faculty exchanges appear to be greatly valued when utilized in the arts departments.

One respondent notes that all new faculty are given a six-unit reduced load the first year, thus providing time for campus acclimation and preparation for teaching and creating. Another reports that, in addition to the university research grants, arts faculty can apply to the college for mini-development grants to aid instruction. These small grants ($300-$500) are to support the development of materials for innovative teaching techniques or to support attendance at special seminars. Several respondents note that music, dance, and theater faculty perform regularly with professional or community groups, often with released time from campus duty; indeed, occasionally such performance is considered a part of their duties. One university reports support for a program for "Reassignment of Duties," which gives performing arts faculty time to practice, perform, or pursue other professional development activities. On the other hand, some respondents note that, while supporting the concept of released time for performing and creating, they feel it is impractical to provide sufficient time away from campus for these activities. A few note special development programs, competitive and designed to recognize quality, variously titled "Critical Thinking Fellows," "Distinguished Scholar Program," and the like.

Guest and Resident Artists

Another mechanism for both faculty development and general campus enrichment is the use of guest artists, resident artists, and resident faculty ensembles. The survey sought information about what entities were utilized on campuses, how they were used, and how were they supported. The vast majority of responses (some 87 percent) report the use of guest artists and/or artists in residence. These artists are of regional, national, or international renown. Most are professional artists; a

few are faculty exchange artists. Their services are engaged in a variety of ways: performances, exhibitions, master classes, and tutorials, often both on the campus and in the community. This campus-community relationship is frequently informal, but some responses report carefully planned programs and processes to ensure the duality. Most stay a brief period or a few days; a few stay a semester or year. Most responding institutions have faculty performing ensembles; few report resident professional ensembles or companies. Though an obviously costly measure, a few campuses report the use of visiting companies for short residencies. A minority (8 percent) of responses indicate little or no enrichment efforts of this nature.

These enrichment programs are supported by an array of funds. Indeed, multiple sources of support for an event or series are the case at almost every responding institution. The most commonly mentioned sources of funds are the university budget and student fees. These sources are frequently augmented by collegiate or departmental funds and private funds (individual gifts, endowments, private foundations, and a few university foundations). Box office revenues and funds from state and/or local arts councils are less frequently mentioned as sources of support; a few receive funds from the National Endowment for the Arts or the National Endowment for the Humanities. Just under one-third of the respondents provide specific budgetary figures, totaling just over $1,975,000. The range of reported budgets is from $3,000 to $165,000, with an average of $31,363. If one multiplies that average by the total number of respondents to the survey (215), it might be estimated that over $6.7 million per year is spent by those institutions on educational-artistic enrichment efforts.

One of the more unique and large sources of support for artistic enhancement programs of this nature is the California Lottery, which provides funds for the individual institutions and the system of The California State University for such programs.

Another university is planning, through an endowed chair, to establish an Artists' Colony for extended campus residencies by artists in all fields. A few campuses note the use of visiting critics in addition to visiting artists. They appear to be especially useful in reaching the general student populaton and the public. Summer theater companies, involving campus faculty and students, are sometimes augmented by professional actors and directors. Several urban universities comment on the professional interchange between campus and community artists and companies, including mechanisms for adjunct faculty and use of campus artists as directors or performers in the community. A few respondents report that some faculty lines are reserved for resident artists, thereby helping ensure new ideas coming into the campus.

Budgets for the Arts

 Seventy-seven percent of the respondent institutions, large and small, urban and rural, report total budgets of $302,642,291 for arts programs as defined by this study. The diversity of institutional programs is reflected in diverse budgets. At one end of the spectrum are budgets of (a) $80,000 for a small, rural college with some 30 students in a single major in the arts and (b) $140,055 for a small, rural college with under a dozen students majoring in the arts. At the other end of the spectrum are budgets of (c) $9,785,317 for a small school specializing in the arts and (d) $9,368,260 for a large, urban university with a wide range of programs for over 2,500 arts major and minor students. The average arts budget for responding institutions is $1,834,195.

 When comparing current budgets with those of five years earlier, 41 percent of the respondents report that the arts budget, as a percent of the total university budget, has increased. Some 37 percent report stable conditions, and only 20 percent note a decline in the arts budget as a percent of the university budget.

Arts Programs for Arts Majors and Arts Minors

Majors and Minors

The state colleges and universities who responded to the survey report arts majors and minors as noted in Table 4.

Table 4: Majors and Minors by Arts Discipline and Degree Sought

Degree	Art	Dance	Music	Theater	Film
BFA,BM	15,180	877	10,077	1,900	114
BA,BS	16,408	486	7,277	4,588	464
MFA,MM	1,111	32	1,948	193	21
MA,ME	1,378	32	843	313	24
DMA	0	0	129	0	0
Phd,EdD	18	12	81	13	0
Total	34,095	1,439	20,355	7,007	623
Minor	2,095	391	1,528	782	39

	Radio-TV	Arts Ed	Interdisciplinary	Other	Total
BFA,BM	1,550	1,454	221	1,643	33,016
BA,BS	10,044	3,633	1,405	5,321	49,626
MFA,MM	3	37	41	129	3,515
MA,ME	134	377	134	267	3,502
DMA	0	0	0	0	129
Phd,EdD	0	9	11	7	151
Total	11,731	5,510	1,812	7,367	89,939
Minor	500	414	177	267	6,193

With over 82,000 undergraduate arts majors reported by respondents, art attracts 38 percent of all those students; music follows with 20 percent. In music and dance, the professional degree attracts the most undergraduate students. This is often

true even in those cases where the student intends to teach or ends up teaching. In theater, film, radio/television, and arts education, the liberal arts degree is the more common undergraduate degree. Art students are almost equally divided into the two degree programs. [The data under "Other (Specify)" are simply too diverse to summarize satisfactorily. They include creative writing, communications, communications/theater, design, art history, art preservation, or nonspecified numbers that might better fit under another category.] Many AASCU institutions have small graduate programs in the arts (as evidenced by the figures) and only 19 percent offer doctoral programs in any area. The majority of students who minor in an arts field chose art or music, fields often sought by elementary education or liberal arts majors.

Responding institutions also report that since 1982 there has been an increase in both majors and minors in the arts. Some 54 percent of the institutions note an increase in majors, 26 percent have experienced little change, and only 19 percent report decreased majors. Similarly, 51 percent of the institutions report an increase in minors, 26 percent report stability, and 12 percent report an enrollment decline.

Respondents were asked to describe any unique curricular characteristics, special requirements, or current issues relating to the quality of the arts programs. The overwhelming number of responses indicate that arts programs seek diligently to ensure the quality of artist-teacher graduates. Many use portfolio examinations and auditions for admissions or placement; a very few use written, professional examinations. One institution reports that it can admit a student on the basis of talent, as determined by audition or portfolio, even if the student is not eligible for university admission. Most require ensemble participation for performing artists, and many use juried critiques for visual arts students. One drama proqram reports a requirement that students pass quarterly faculty committee reviews. The most frequently mentioned efforts to ensure quality are required

exhibitions, recitals, and/or performances. Many programs use internship or work-study programs (usually for credit) to augment students' experiences. These may take the form of radio-television technical or on-air work, service as arts teacher's aides in schools, employment in professional arts businesses, summer employment in performing arts companies, and other such endeavors. Institutions report special courses or programs endeavoring to keep the students current. These include such activities as a world music program with ethnic ensembles, programs of international study, minority arts courses, modern art history curricula, a biomedical illustration curriculum, arts therapy clinical work, a museum certification program, a Black Theatre and a Chicano Theatre, a bilingual puppetry course, a senior thesis and portfolio development class, artists-in-residence programs, and computer arts.

Another question sought information on employment of arts graduates. A few respondents report little or no specific information available. A few institutions offer specific information with supporting statistics. Most, however, respond in an informed but general way. The most frequently mentioned employment is teaching; professional art is second; commercial art and graduate study are third and almost equal. However, the patterns vary according to the arts discipline; therefore generalizations about arts employment are risky. The most frequently mentioned career for the music graduate is teaching, often in an elementary or secondary school. Careers for art graduates most frequently noted are in professional or commercial art (graphics, design, etc). Theater graduates tend to go into professional theater work in a variety of capacities and kinds of theaters. Radio-television graduates find employment in the profession (broadcasting, technical, public relations, etc.). In many of these disciplines, graduate study is a part of the pattern at some point. It must be remembered that the patterns are generalizations; there are many exceptions to the rule. For example, many musicians perform and many visual artists teach. A few respondents report

that graduates did not enter arts employment, but utilized the degree program as a liberal arts experience for other employment (including medicine, law, computers, and a wide range of others). Other studies and analyses have shown that some individuals do not enter arts employment because they are unable to find employment in their discipline or geographic region or for other personal reasons.

Community College Transfer Students in the Arts

This study specifically sought information about transfer students majoring or minoring in the arts. Historically, most students studying in the arts have matriculated at four-year institutions. However, new programs, rising costs, and different student profiles have caused some changes over the years. Responding institutions indicate that, since 1982, the number of community college transfers has either remained stable (42 percent of reporting institutions) or increased (39 percent); only 17 percent of the institutions report a decline in the number of community college transfers in the arts. Community college transfers account for approximately 9 percent of all undergraduate majors and minors reported in the arts. More specifically, the numbers of majors and minors who transferred into the various disciplines, as reported by respondents, are noted in Table 5.

Table 5: Number of Transfer Students Majoring or Minoring in Arts Disciplines

Discipline	Majors	Minors
Art	3,269	131
Dance	120	46
Music	1,271	129
Theater	746	125
Film	26	3
Radio-TV	936	133
Arts Ed	423	65
Interdisciplinary	42	0
Other	590	38
Total	7,423	670

Following the general pattern of majors and minors, most transfer students pursue degrees in art (44 percent), music (17 percent), radio/television (13 percent), and theater (10 percent). (Not enough information was provided by respondents about the "Other" category to provide any meaningful report, but it may be safe to assume that the degrees are in many of the disciplines reported for all majors.)

Respondents were asked whether they had articulation agreements with community colleges for students entering arts programs and whether they had any particular successes or problems to report about transferring students. Over 80 percent of the respondents provided information, with the vast majority (73 percent) indicating that articulation agreements are in place, either at the university, collegiate, or departmental levels. Of those, a number indicate that the transfer process includes a portfolio examination, an audition, or a written exam in such subjects as music theory. These diagnostics are used to determine the artistic quality of the student work and may be used in awarding credit, advising, or placement. (Based on other experiences, this writer has reason to believe that many institutions who did not mention the portfolio/audition requirement nevertheless do have that requirement in their articulation agreements.) In rare cases, excellent examples of cooperation included faculty exchanges and senior faculty working with community college student portfolios. Some 21 percent report no articulation agreements, and 5 percent report that agreements are being developed.

Of those reporting articulation agreements, 11 percent indicate that some "problems" or "conditions" or "issues" exist in the transfer process. Those issues include accepting arts credits only as electives, requirements that certain courses be taken at the senior institution, concern about the perceived or real inferiority of arts instruction (primarily in music and visual arts, and to a lesser degree, theater) at some community colleges, concern about small arts faculty at community colleges resulting in fewer

arts options, and concern about differing missions and differing grading standards in the light of those missions. On the other hand, a few institutions accept all transfer credits without question (sometimes when mandated by policies) and then frequently review the progress of the student.

Minority Students in the Arts

AASCU institutions have historically been colleges of opportunity for many students, including an increasing number of minorities. The arts are most often free of racial or ethnic bias, with creative ability the primary criterion for success. Respondents were asked specific questions about the number of minorities majoring or minoring in the arts disciplines. The reported enrollment patterns are found in Table 6.

Table 6: Number of Enrollments of Minorities in Arts Disciplines by Degree Goal

Discipline	Bachelor's	Master's	Doctoral	Total	Minors
Art	2,464	255	3	2,722	89
Dance	163	3	3	169	67
Music	1,217	192	3	1,412	119
Theater	437	37	0	474	61
Film	34	3	0	37	0
Radio-TV	1,283	6	0	1,289	152
Arts Ed	422	12	3	437	27
Interdisciplinary	171	7	0	178	1
Other	571	37	0	608	26
Total	6,762	552	12	7,326	542

Minority students constitute just over 8 percent of the reported undergraduate majors in the arts, just under 8 percent of graduate enrollments. More minority students major in art (36 percent), radio/television (19 percent) and music (18 percent) than in the other disciplines; the order of the latter two is reversed

for all undergraduates in the arts. Theater and arts education rank fourth and fifth in undergraduate enrollment for all students and for minority students.

Compared with 1982 figures, numbers for minority students majoring or minoring in the arts are reported constant by most respondents (44 percent) or increased (40 percent). Only 16 percent report a decline in minority enrollments in the arts disciplines in the last five years.

Respondents were asked to state the number of students by ethnic group for the arts school/college. Many respondents did not have this information or reported it in a fashion that made it incompatible with other data relating to minorities in all arts programs. Therefore 97 institutions with accurate and compatible data were examined to determine the representativeness of their respondents data. The institutions broadly represent the AASCU members in size and geographic location. They also represent 54 percent of all minority students reported in the arts and 47 percent of all the arts students reported by respondents. Their data indicate the percentages of various minorities majoring and minoring in the arts in Table 7.

Table 7: Race/Ethnic Group Percentages Reported as Arts Major or Minor

Race/Ethnic Group	% Enrolled as Major or Minor
Black (Non-Hispanic)	45%
Hispanic	16
Asian	17
American Indian	2
Native Alaskan	2
Polynesian/Pacific Islander	1
Other	17

The largest reported percentage of minority students in the arts are Black students, followed by Asians and Hispanics. This

pattern is not unlike patterns for arts students graduating from a wider range of universities.[2]

Arts Programs for Non-Arts Major or Non-Arts Minor Students

Enrollment Patterns and Types of Courses Offered

Three-quarters of the responding institutions report 244,958 enrollments in arts courses by students who are neither majoring nor minoring in an arts discipline. Those enrollment patterns are noted in Table 8.

Table 8: Number and Percentage of General Students Enrolled in Arts Courses

Arts Discipline	Non-Arts Majors and Non-Arts Minors	
	Number	*Percentage of Total*
Art	75,259	31%
Music	85,142	35
Dance	12,113	5
Theater	31,348	13
Film	3,450	1
Radio-TV	10,897	4
Arts Ed	5,486	2
Interdisciplinary	4,779	2
Other	16,484	7
Total	244,958	100

Music and art courses are the most popular electives in the arts curricula. Two factors may contribute to this. First, elementary education majors often elect or are required to take courses in these two art forms; second, participation in a performing music group (e.g. band, choir) may attract students.

Each arts discipline reflects an array of courses available to the general student population. Table 9, based on information by nearly three-fourths of the respondents, shows the pattern of instructional vehicles.

Table 9: Percentages of Types of Courses
Offered to General Students by Arts Discipline

Arts Discipline	Lab	Lecture	Survey	Lessons	Other
		% of Courses Offered			
Art	31%	33%	28%	5%	2%
Music	18	29	24	24	6
Dance	38	27	13	16	7
Theater	27	38	26	6	4
Film	15	49	34	2	0
Radio-TV	33	39	23	4	2
Arts Ed	34	43	10	7	6
Interdisciplinary	15	40	38	2	5
Other	34	41	23	0	2

Not surprisingly, laboratory, lecture, and survey courses compose the greater percent of course offerings to the general student in every art discipline. Because of the nature of the disciplines, art and dance curricula offer a greater percent of laboratory experiences to the general student; music, more individualized instruction.

Some 64 percent of the institutions report an increase and 29 percent report stability in arts enrollments by the non-arts major or minor since 1982. Only 7 percent report a decrease in these enrollments. This is an encouraging development in terms of a future, positive arts climate. It may be a reflection of the growing number of institutions now requiring or offering at least one arts course as a part of the general education curriculum for all students, currently at 61 percent.[3]

Two questions sought information about curricular requirements for or trends in arts courses for the non-arts major or non-arts minor and about arts/cultural opportunities for the general students. Of the 70 percent of the respondents who provided curricular information, some 49 percent report that one or more arts courses are required for all university students as a part of the general education requirements. Indeed, of that group, 13 percent require two or more arts courses. Some 7 percent require two or more arts courses for arts and sciences students. Another large segment (44 percent) offer arts courses as an elective option within the general education requirements. Only two instances were reported where general education requirements had a negative effect on arts elective enrollments. In most cases, the choice of courses within the requirements appears to be fairly broad, at times including participation/performance courses. A few institutions describe how course outlines must be submitted to college and university committees with an explanation of how each course can introduce a student to the discipline. In a few cases, specific courses are mandated, such as art appreciation, music appreciation, or integrated arts.

Responses to the question concerning what arts/cultural opportunities are available to the general student provided few surprises to anyone who has worked in the arts on campus. The most frequently reported opportunity is attendance at film series, concerts, plays, and dance performances by student, faculty, and touring performers. These events are usually free of charge or available at student discount rates. Another artistic opportunity frequently noted is exhibitions or art shows by emerging and professional artists. The third most frequently noted artistic endeavor for the non-arts student is the ability to audition to become a part of musical ensembles and theater productions. Elective courses beyond the general education requirements, field trips, minicourses, and arts clubs are noted as well. Radio and television, both NPR/PBS and campus-oriented (including cable), are also noted as means for students to enjoy the arts. One

university reports requiring all students to attend at least three cultural events for every 15 credit hours completed at the institution.

These responses reinforce the idea that the student who is majoring or minoring in some discipline other than the arts can still have ample opportunity to learn about and enjoy the arts through courses and events. Most campuses provide a wide array of offerings that can enrich any student.

Arts Programs for Community Outreach

Most successful arts programs at institutions of higher education serve both the campus and community. This study sought to elicit information about the extent of outreach efforts by AASCU-member institutions. When asked what kind of "arts services" institutions offer to their community constituents, the respondents report a wide array, as demonstrated in Table 10.

Table 10: Types and Prevalence of Arts Outreach Services

Type of Outreach Service	% of Respondents Reporting Service
Recitals	96%
Plays/Theater Presentations	93
Opera	56
Musicals	83
Dance Presentations	57
Courses of Study	54
Workshops/Seminars	79
Performing Opportunities	71
Tours	64
Exhibits	90
Preparatory Classes/Lessons	46
Other Services	25

The audiences reached and served by these services are broad and diverse. They include students, school children, adults, senior citizens, the incarcerated, the handicapped— people from all parts of the campus and community.

Arts Organizations/Facilities

Performing Ensembles

For a better picture of the cultural climate of the campus and community, respondents were asked to indicate what kind of performing ensembles existed on their campus, to indicate its composition (e.g. students, faculty, students/faculty), to indicate whether admission was generally charged, and to indicate whether the ensemble was generally available for touring.

Most responding institutions report having a choir, band, and theater performing group. Nearly three-fourths of the responses note an orchestra, smaller instrumental and vocal ensembles, a jazz ensemble, and solo performances. Almost half of the responding institutions report children's theater, opera-musical theater, and modern dance groups. Only a few institutions report having a ballet company and ethnic performing arts companies.

The "mix" of artists in the various performing groups is interesting. Table 11 indicates the percentage of reported ensembles having students only, faculty only, or students and faculty. It also reports the percentage of those ensembles that usually charge admission and the percentage that are available for touring in the region.

There is a wide array of performing organizations on the campuses of AASCU institutions. Some charge admission fees; many are available for touring. With respect to touring, some 74 percent of the responses indicate that the university subsidizes tours of its performing groups, but only 6 percent report full subsidization. Those funds used in subsidization are from

operating budgets (21 percent), student fees (20 percent), and other sources (59 percent). These facts demonstrate the institutions' interest in serving students and faculty with creative opportunities and in improving the quality of life for community constituents through outreach efforts.

Table 11: Performing Ensembles: Composition, Fees, and Touring Availability

Type of Ensemble	Percent Students Only	Percent Faculty Only	Percent Students/ Faculty	Admission Generally Charged	Generally Available for Tour
Orchestra	35%	0	63	29	34
Band	74	0	26	16	70
Choir	71	0	29	16	70
Madrigal	83	0	16	33	57
Woodwind	53	7	39	15	57
String	47	17	37	17	54
Brass	55	6	38	12	61
Percussion	79	1	20	11	54
Theater	47	0	51	86	30
Children's Theater	67	0	32	74	52
Modern Dance	61	0	38	74	57
Ballet	73	5	10	63	53
Jazz	68	1	31	25	73
Ethnic Dance	50	0	44	44	69
Ethnic Music	64	0	36	23	68
Ethnic Theater	0	0	0	0	0
Opera-Musical	58	0	42	71	25
Solo Performers	11	10	79	20	64
Other	48	10	33	33	58

Arts Facilities

Both through data and narrative submissions, many institutions report extensive and excellent arts facilities used for

instruction and presentations to members of the campus and the community. A total of 190 responding institutions report data on arts facilities as noted in Table 12.

Table 12: Facilities: Percentages with Facility; Average Capacity, Staff and Operating Budget

Type of Faciltiy	% with Facility	Average Capacity	Average # Staff	Average Budget
Auditorium	85%	867	1	$4,842
Concert Hall	29	601	1	3,355
Recital Hall	68	224	1	629
Theater	100	362	1	7,193
Gallery	97	—	1	7,576
Museum	20	—	3	73,501
Other	26	—	1	26,024

Total budgets for arts facilities are reported to be $7,908,954, with an average of $41,621. Over 900 total staff members are reported to operate those facilities. Repondents note almost equal use of a facility by faculty, students, and visiting artists; the public uses the facilities about 15-20 percent less than those groups. As further evidence of institutional commitment to serve the widest possible audience, 91 percent report that the arts facilities were generally accessible to the disabled audience, 93 percent accessible to underserved populations, and 94 percent to the general community.

Respondents were asked to describe any efforts of their arts programs to reach underserved and/or culturally diverse audiences. The breadth of the question was matched by the breadth of responses. Chapter 4 of this book includes more specific examples of these efforts, but certain generalizations can be drawn here. The most frequently noted effort is the use of touring groups and artifacts to bring the arts to communities, centers, and schools that might otherwise be underserved. These forms

of outreach include music groups, theater groups, dance groups, minicourses, and exhibitions. The events, at times, are provided to special audiences such as the handicapped, senior citizens, and youth. They sometimes deal with subjects of special interest to minorities, women, youth, or the incarcerated. The events are usually free or provided at modest cost so that no interested individual is denied access. There are isolated reports of special "interface" programs and community-based arts centers for youth and minorities. Another major means of reaching beyond their usual constituencies, as reported by the respondents, is the use of media—print, radio, and television. Both in terms of advertising campus and off-campus events and as a cultural/educational vehicle, the media successfully reach new audiences. This appears especially true in vast regions, areas with high crime, and centers with older citizens. Mentioned less frequently are such efforts as cosponsoring arts series with cities and providing workshops or minicourses in various areas of the community. On campus, those institutions with especially diverse student populations offer courses, workshops, performances and exhibitions of the arts of Native Americans, American Indians, Africans, Hispanics, and Asians. A few universities note curricula or select courses having an international and multicultural perspective. It appears that most respondent institutions take this outreach responsibility rather seriously and are collectively creative and expansive. Only a handful of respondents (about 4 percent) say little is being done to reach underserved and/or culturally deprived audiences.

Respondents were asked to describe special outreach/arts services relationships they might have with precollegiate schools (elementary or secondary) or community colleges. The array of outreach efforts reported is extensive. The most often-reported methods of college/school outreach are in-school performances by university groups and university faculty visits to schools and community colleges for classes, performances, or presentations. Arts festivals, contests, and student art exhibitions; workshops

for students and teachers; active recruitment, with scholarships, of students with great talent or potential; and special university/school relationships, such as adopt-a-school, are also noted as effective means of strengthening ties with school students and teachers, enhancing both the schools and the university. Mentioned less frequently, but seemingly valued by the respondents who reported them, are relationships with special governor's schools, community schools, or high schools for the arts; "guest students" for college credit and early admissions programs; Saturday classes; summer camps and workshops; career days, on-campus tours and performances, including children's theater; and service as teacher's aides by university students. Meaningful contact with elementary and secondary schools and community colleges appears to be valued by state colleges and universities. Energy and resources are put into these efforts, to the apparent benefit of all concerned.

Respondents were asked to describe any special features of their arts outreach-service efforts. The most frequently noted feature is the development of strong university-community relationships. This activity includes making the university arts available to communities and schools, both on- and off-campus; enhancing the community environment through the arts; utilizing the arts resources of the community to improve and complement the university offerings; and cooperatively supporting cultural enrichment efforts such as concert series. A second valuable outreach-service feature of a number of campuses is the work of their students in the schools, with the underprivileged, in social services centers, and with arts groups. The university faculty's work in schools and communities is another valued aspect of outreach. Finally, there are isolated reports of the value of international competitions, study abroad programs, artists-in-residence, community institutes for the arts, early admissions programs, and direct, ongoing contact with prospective students.

Environment

This study elicited information on the settings in which state college and university art programs are found and what effect those settings have on the programs. Some 84 percent of the institutions classified themselves: 56 percent are located in rural or small town settings; 44 percent in urban or suburban settings. And indeed, those settings do, to some degree, influence the arts offerings on- and off-campus. Rural campuses find themselves to be the primary arts provider for their campus and region; the cultural centers. As one respondent noted, "Because of our rural location, the arts offered by the university have a very large effect upon the campus and the community. Providing an arts environment for the university and for the northwestern section of [the state] is regarded as a mission of the arts departments. This mission includes not only presentation of materials on campus and touring of many presentations to various communities, but also active support of local arts councils, theater groups, arts associations, concert groups, etc."

Urban campuses, while centers of the arts, find themselves interfacing with the city's arts endeavors. Most often, this enriches the campus as students and faculty benefit from the cultural environment of the city. It was reported, "There is an easy interchange among faculty/students and professional arts groups in the community"; "Great access to museums and galleries. Cross registration with other arts schools in the area." Only four institutions found that the urban setting create problems with conflicting arts events or the commuting audience.

However, it appears that the respondents, being creative artists, adapt to their conditions and work to make the arts flourish for the campus and their region.

Though difficult to assess objectively, institutions were asked to describe the overall effect of the arts on the quality of life on the campus and in the community. Some 64 percent of the respondents attempted to provide that perspective. Some 82 percent of the responses indicate that the arts are a good (27

percent) to a very good/significant (55 percent) influence on the qualilty of life of the campus and the community. Another 8 percent rank the influence as fair. Only 10 percent feel that the arts have a limited effect, especially with respect to non-artists.

Among the positive responses were:

■ "98% of all of this university's outreach and service is provided by the various arts departments."

■ "The only show in town."

■ "In some ways reach a larger audience than athletic events do. The impact of the arts on campus and community life is positive and can be traced in large part to the aggressive interest in and support for the arts by the university president."

■ "The school of fine arts creates a cultural arts center for the campus as well as for the region. With the large increase in the number of nonmajors participating in arts activities, the number of students remaining on campus during the day and evening has increased and attendance at arts events has benefited from this increase in student participation."

■ "We are essentially the only center of activity for serious educational programming in the fine and performing arts."

■ "For a small rural community—excellent!!"

■ "Contribute greatly. I'd hate to be here without them."

■ "The wealth of recitals, plays, films, and other performances offered each semester provide students, faculty, and members of the community with more cultural opportunities than anyone can take full advantage of. This high-quality cultural and artistic

activity is a considerable enhancement of campus life, and it attracts a large off-campus audience."

■ "Our university is in an urban setting. . . . The university arts programs/offerings help to integrate city and campus populations into a whole, both as participants and audiences."

Among the few discouraging reports were:

■ "We try, but the public interest is not strong, except for musicals."

■ "We are not well attended by the campus community."

Practical Benefits

Finally, it is acknowledged that the arts, while having significant intrinsic aesthetic values, also have certain extrinsic values. Respondents were asked to note in what nonartistic ways the arts are an asset to their campuses. Four primary responses are given. The most often stated is enhanced public relations. Simply put, "They significantly raise the campus profile in the community," or "The arts programs . . . function as our 'football team.' We are perhaps one of the most visible and celebrative aspects of [the campus] before the public." The second most cited benefit of the arts is enhanced student and faculty recruitment. It is reported, "It is not uncommon for entering freshmen to report that their opinion of the college was formed during a pleasant experience such as an arts performance on campus during their early years," and "The university arts program ensures the intellectual environment needed to attract and retain quality university personnel." The value of the arts in fund raising is noted often. A respondent notes that "fund-raising efforts have been enhanced by the contacts which have been established between the university and the community in various art-related endeavors." Several comments are made about the arts' improve-

ment of the quality of life in a community. As noted, "The college of fine arts is an asset because we provide cultural activities, pride, energy, and jobs. The arts are nothing less than a vital human resource to the region."

One respondent sums up the nonaesthetic values of the arts programs at public colleges: "The arts provide a viable focus on the university in general. Through attendance of art exhibits, concerts, recitals, and theater, students, faculty, and the public are made aware of the opportunities available and consequently become interested and involved in other aspects of the university. Recruitment, publicity, and fund raising are not measured by the participation and attendance of the cultural opportunities provided, but the arts are recognized as a vital and important means for portraying the university as a center for cultural opportunities, learning, leadership, and excellence."

Findings and Recommendations

■ Most respondents report a stable or increasing arts faculty. In the light of general university budgetary concerns, this finding reinforces the recognized value of the arts as a part of the academic community.

■ The reasonably high number of part-time faculty in the arts may be attributable to several factors: small enrollments in specific areas, the need for specialized arts skills to broaden the curricular offerings, or the wish of some arts faculty to maintain considerable time for producing their own art. Part-time faculty can do much to enrich the arts on campus, provided that the institutions maintain a solid and substantial core of full-time personnel to ensure continuity and quality.

■ The reports of stable and increasing numbers of minority faculty members in the arts complement the reports of stable and increasing numbers of minority students in the arts. However,

the relatively few minority faculty members reported in film and arts education could bode ill for minority students who are seeking role models in these fields.

■ Faculty development programs generally appear to be available to and valued by faculty and administrators. Campus programs are obviously enriched by a faculty that is current in its field, creative, and energized by professional growth. Although many respondents appear to feel that the programs were satisfactory, many others indicate that more funds could be used effectively. Only a few express concern about lack of support for faculty development. Even so, this appears to be an area for continued vigilance and development.

■ The use of resident and guest artists appears to be fairly extensive, and there are practically no reports of tensions between visiting artists and faculty artists; indeed, it appears that resident and guest artists are viewed as enrichments for faculty, students, and community residents.

■ The increasing and stable arts budgets, at a time when many universities are facing financial problems, may demonstrate the value placed on the arts as a part of the academic and general communities.

■ The majority of institutions report an increase of arts majors and minors; a substantial portion report stable conditions. These reports are encouraging in terms of future artists and audiences.

■ The variety of requirements, options, and enrichments offered by arts programs support the contention that arts faculty are dedicated and inventive in their efforts to ensure quality education. Additional reseach might be conducted to determine the effect, if any, these opportunities have on the length of time

needed to complete an arts degree *vis-a-vis* other academic disciplines.

■ The lack of specific information on employment patterns of arts graduates by some institutions would indicate that more attention should be given to this issue. Effective long-range planning must reflect specific information of this type; institutions that are not effectively collecting such information are at a disadvantage.

■ The stable or increasing numbers of community college students transferring into arts programs would seem to require thoughtful and carefully-drawn articulation agreements. Most respondents report having articulation agreements or transfer understandings that present few problems. Some note that developing such agreements results in improved communication between the institutions and in higher quality transfer experiences. However, where problems exist, be they real or imagined, it is incumbent on both institutions to try to improve conditions for the sake of arts students.

■ While the fact that the numbers of minority students in the arts remain stable or are increasing, colleges and universities must be vigilant to ensure that these patterns continue or improve and that the curricular and cocurricular programs in the arts are sufficiently multicultural to be responsive to both the general and arts student populations. Furthermore, to encourage minority students to think of the arts as a profession, institutions should continue cooperative efforts with elementary and secondary schools.

■ A high percentage of institutions report an increase or at least stability in enrollments in arts courses by general (non-arts major or non-arts minor) students. While this is encouraging in terms

of future arts literacy in the nation, it demands that the course offerings be engaging, demanding, significant, and rewarding.

■ Colleges and universities reportedly value the arts as enrichments for their campuses and their regions. Therefore, there is extensive use of performing ensembles, exhibitions, plays, and the like to reach both students and community residents. New and improved arts facilities enhance these efforts. Further, a wide variety of arts outreach efforts are employed by institutions to reach the young and old culturally advantaged and culturally disadvantaged. Institutions recognize both the intrinsic and extrinsic values of the arts for their campuses.

■ The widely held perception that state colleges and universities serve as cultural centers for their regions has been reinforced by this survey. And there is considerable indication that colleges and universities are assuming an even greater responsibility in this role.

Notes

[1]Throughout this study, "number" refers to actual count, not to full-time equivalent.

[2]Report from the Office of the Assistant Secretary for Civil Rights, U.S. Department of Education (Washington, D.C., 1986-87) p. 2158.

[3]Elaine El-Khawas, "Campus Trends, 1989," *Higher Education Panel Reports* Number 78 (Washington, D.C., American Council on Education, 1989), p. 35.

4

Arts Programs at AASCU Institutions

The more than 370 member colleges and universities and 30 member statewide systems of higher education of the American Association of State Colleges and Universities (AASCU) are as diverse as America itself. Some are former teachers colleges, others are freestanding units of multicampus state universities, and still others are municipal institutions and community colleges that became comprehensive state universities. Some are specialized state institutions of higher education, such as maritime academies and performing and fine arts schools. And among AASCU institutions are more than 110 new public colleges and universities established since World War II. They range in size from small colleges of about 400 students to large, comprehensive universities of more than 33,000 students. Almost one of every three students attending a four-year institution in the United States enrolls at an AASCU institution. Each year, more than 300,000 bachelor's degrees are awarded by AASCU institutions, representing approximately 32 percent of the total number awarded in the nation. About 80,000 master's degrees are awarded, representing approximately 27 percent of the total. And over 2,200 doctorate degrees are also awarded each year.

Yet, within this diversity, there are some common threads. These institutions are all tax assisted, they are colleges of opportunity for many students, they are accessible and affordable, they are student oriented, they serve as the educational hub of their region, and they reach not only their students but also their communities and regions with their teaching, research, and service.

The Arts at AASCU Institutions

The following descriptions of programs at AASCU institutions, provided by the institutions, illustrate the breadth and depth of arts activity in public higher education. Not all endeavors appear to be of equal scope or impact. Yet each is important to the campus and region served. The selected list is not exhaustive

but demonstrative: it reveals both the diversity and the common-ality of the program offerings. The most common theme is that the universities, through their arts programs, become cultural centers for their communities and regions.

Alcorn State University (MS)

Established in 1871, Alcorn State University is the oldest predominantly Black land-grant college in the United States. Although Alcorn State is committed to development of educa-tional programs to serve the best interests, needs, and aspira-tions of talented students, it is also sensitive to and active in educating those students who must overcome the obstacles of socioeconomic and cultural deprivation. In an effort to address this latter audience, the department of fine arts instituted a program in computer-assisted instruction. The CAI laboratory was originally established to provide developmental instruction for students with weak backgrounds in music theory, music history/literature, and art appreciation and humanities. A videodisc series, with a laser disc and a 26" high-resolution stereo television monitor, has provided faculty and students with exep-tional and more flexible courses in appreciation, theory, and humanities. The system includes capabilities to incorporate artistic works, cultural background, pictures, and music scores with motion picture, slide projector, and phonograph. Sequences can be set up to present slides from a data bank; the entire collection of the National Gallery of Art can be viewed on vide-odiscs. In addition to purchased software, programs are being written by members of the department to better serve the entire university community. Although originally intended for develop-mental purposes, the CAI laboratory now provides extensive enrichment experiences for all students in art, theater, music, and humanities. Plans are under consideration to determine the value of this equipment for student recruiting and for providing area elementary and secondary schools and the general commu-nity with access to music, art, theater, and dance experiences.

Appalachian State University (NC)

Appalachian State University (ASU) is located in Boone, North Carolina, in the heart of the Appalachians. ASU offers some 130 academic majors at the baccalaureate level and over 70 at the master's level. Although the university's main mission is instruction, it is also dedicated to serving the region. ASU is the home of the Center for Appalachian Studies, which develops programs and projects in such areas as the arts of the region and social and cultural issues. The college of fine and applied arts offers academic programs in art, dance, music, and theater to train young professionals and educate arts teachers. In addition to the campus programs, the university maintains two remote campuses: the New York Loft, for arts programs, and Appalachian House, next door to the Folger Shakespeare Library in Washington, D.C. One program of note is "An Appalachian Summer," a summer-long festival of art, dance, music, and theater. In the summer of 1983, a handful of people with picnic baskets and an appetite for summer cultural activities gathered to hear an ensemble from the North Carolina Symphony Orchestra perform concerts on a campus hill. Four years later, over 50,000 people attend "An Appalachian Summer" enjoying offerings in all the arts. The 1987 festival included a three-week residency by the North Carolina Symphony Orchestra, whose members worked with students attending ASU's Cannon Music Camp. The Acting Company (the touring arm of the Kennedy Center), the North Carolina Dance Theatre, the Broyhill Ensemble, gallery exhibits, an invitational outdoor sculpture exhibition, events from the Smithsonian Institution, folk music, mountain music, and barbershop quartet singing have all been a part of the festival. With the establishment of "An Appalachian Summer," ASU has become the region's focus for the arts during the summer months. These activities are enabling the university to develop into a center for the arts throughout the year.

Arkansas State University

Located in northeastern Arkansas, Arkansis State University is the second-largest university in the state and offers degrees through the specialist level. Its community, Jonesboro, is a city of 30,000 people and the trade, financial, medical, cultural, and educational center of that corner of the state. The region is largely agricultural, but small industries are growing. The college of fine arts is the largest fine arts program in Arkansas and offers bachelor's and master's degrees in art, music, and speech communication and theater arts. Largely dependent on state-appropriated funds, the programs have, in recent years, received modest support from the Arkansas Arts Council for public programming and from private gifts. One outgrowth of this tripartite support is the Visiting Artists Series. Beginning with a small program of visiting artists, usually in the form of faculty exchanges, the art department established the Visiting Artist Series to enhance its own programs and to enrich the community at large. With the participation of artists such as Sam Gilliam, Alice Aycock, Duane Hanson, Barry Moser, and Robert Colescott, the series has fulfilled the hopes of the founders. It greatly enhances curricular offerings for students, cultivates increasing public awareness of the arts, furthers good relations between the university and the community, increases university/community collaborations and fundings, and enriches the artistic life of a relatively isolated area.

Arkansas Tech University

Arkansas Tech (ATU), a multipurpose state university, is located in Russellville, between the mountains of the Ozark National Forest and of the Ouachita National Forest. One of the four schools serving some 3,500 students is the school of liberal and fine arts. ATU, by virtue of its location and mission, acts as a service center for its constituents. One special feature of ATU's service to its region is its Arts Encounter program. Arts Encounter provides high school students with the opportunity to im-

merse themselves for two weeks in music, art, dance, and theater. Selected students are provided this enriching experience at no cost; it is funded by the AEGIS program of the Arkansas State Department of Education and hosted by Arkansas Tech. The program helps students develop an appreciation of and aesthetic sensitivity to the arts. The students learn how to create new works of art, building on the techniques and compositional devices of masters. Further, the program is designed to help the students see how the arts function in society. Such topics as the role of the arts in ceremony, the influence of the arts on social and political thinking, and, conversely, the influence of social and political ideas on the arts are extensively explored.

Ball State University (IN)

Ball State University is a comprehensive, mid-size university in Muncie. The university offers more than 140 major and minor areas of study through six academic colleges. One area of student development permeating all programs is computer competency. With substantial support from the state legislature, the university's computer competency program is in its fifth year. In the college of fine arts, computer competency assumes an uncommmon form. While students are educated in traditional ways within their art forms, they are also being prepared for the most current applications of technology in their disciplines and beyond. Computer competency is gained within an interdisciplinary environment in which students and faculty acquire skills, manipulate visual and sonic material, and create with cutting-edge technology, applying innovative software to expand artistic expression. All fine arts majors are required to take a nondepartmental course, "Computers in the Fine Arts." Instruction is led by an interdisciplinary artist who assists students in each discipline—art, music, theater, and dance—in exploring the art form while gaining competency in using computers and related technology. Though the major portion of the program is coordinated by resident faculty, a steady stream of practicing artists

who use advanced technology in their art occupy miniresidencies throughout the year. The instructional environment of the 30-station laboratory lends itself to inspiration and collaboration. For example, visual image digitizers are placed near musical keyboards and mixers. Technical aspects of theater and dance (lighting, set, and sound design) are approached by students in stations furnished with specific peripherals in carrels, rather than rows of identical machines and printers. Two of the results of the program have been the enhancement of interdisciplinary arts and the greater understanding of how artists in other areas create their art. Faculty and student participation in computer-generated or -assisted art continues far beyond the formal course of study.

Bloomsburg University of Pennsylvania

Previously a teachers college, Bloomsburg University (BU) is now a multipurpose state institution offering programs to over 5,000 students in the areas of liberal arts, business, nursing, allied health sciences, and teacher education. One of 14 universities in the Pennsylvania State System of Higher Education, Bloomsburg University has recently placed a great emphasis on culture and the arts. A greatly expanded Celebrity Artist Series, featuring world-renowned artists, and a cultural newsletter for the region have been instituted. With this climate, Bloomsburg University was selected to serve as host for the 1989 Governor's School for the Arts, the first selection of a university in the state system. BU joined four other universities hosting governor's schools: Penn State (agricultural sciences), University of Pennsylvania's Wharton School (business), University of Pittsburg (international affairs), and Carnegie Mellon (science). The five-week school of the arts program brought together 200 of the state's most talented students, selected from over 2,000 applicants, in the fields of visual arts, creative writing, dance, music, and theater. A staff of 25 resident advisers, 23 faculty members, and five program assistants supported the program on campus.

In addition to helping students explore new techniques and processes in their respective art fields and expand their creative abilities, the program teaches students how to share and promote the arts in their home schools and communities. The Governor's School program has been operating since 1973 and is sponsored by the Pennsylvania Department of Education and the state's intermediate units. An alumni pool consists of some 4,000 artists who enrich their art forms and environments.

Boise State University (ID)

Boise State University is a regional, comprehensive university with undergraduate and graduate programs. As mandated by the State Board of Education, Boise State places primary emphasis on business and economics, the social sciences, public affairs, interdisciplinary studies, and the performing arts. Through the arts, Boise State seeks to strengthen its educational programs, to enhance cultural opportunities for its constituents, to extend those opportunities to a wider audience through media, and to promote economic development and tourism in the state and region. Among the units that support these endeavors are the art, music, and theater arts departments, KBSU radio, Cable-TV Channel 27, the Pavilion, and the Morrison Center for the Performing Arts. Given the university's location in the only large metropolitan area in an otherwise primarily rural state, the arts programs face a unique challenge. On the one hand, university programs must coexist with, and complement, an array of thriving community arts organizations. On the other hand, university arts programs must reach out to culturally underserved audiences in rural communities. Thus, "partnership" and "outreach" are key words in this strategy. The formal affiliation between the Boise State University theater department and the Idaho Shakespeare Festival, a professional theater company, exemplifies the university's endeavors in implementing this strategy. Through a mutually beneficial and cost-effective partnership, the festival's artistic director is responsible for the summer

season and, during the off-season, teaches and directs at Boise State. He produces at least one University/Shakespeare Festival coproduction annually. In their inaugural collaboration in 1987, the University/Festival staged *Macbeth* in the Morrison Center. The cast included professional actors, members of the community, and students. More than 8,400 attended the production, including 5,000 public school students from 52 secondary schools throughout Idaho. As a further outreach effort, a videotape documentary on the making of the coproduction was filmed for airing on Boise's public access cable television channel and for distribution to schools, civic clubs, and arts organizations throughout the state. Through this successful partnership, Boise State theater students not only gain additional experience by working with members of a professional company, but also benefit from workshops conducted by the Festival's resident or visiting experts in costuming, set design, stage combat, and the like. The Idaho Shakespeare Festival benefits from an extended season, increased finances, access to excellent theater facilities, and greater visibility.

Bowling Green State University (OH)

Bowling Green State University (BGSU) has over 17,000 students pursuing degrees in 170 undergraduate program, 75 master's programs, and 12 doctoral degree programs. Of the more than 100 buildings housing these programs, over half have been built since 1960. Included in this category are library facilities with recording archives, art studios and a gallery, radio and television facilities, the Eva Marie Saint and the Joe E. Brown theaters, and the Moore Music Arts Center. The on-campus arts programs for young professionals are strong and successful. In addition to those efforts, BGSU has developed a significant arts education outreach program entitled Arts Unlimited. The purpose of Arts Unlimited is to make aesthetic education an integral part of every child's schooling. This is accomplished by stressing the perception of aesthetic elements in specific works of music,

art, dance, and theater so that children not only begin to see what makes a performance or exhibition successful but also to become able, eventually, to make informed choices about the aesthetic quallity of their own environment. The approach of this venture is modeled after Lincoln Center Institute (NY), but is modified to meet the particular needs and strengths of schools and art institutions in rural northwestern and central Ohio. The program reaches the classroom teacher, his or her students, and the artists and arts resources of the university and the larger community. It includes summer workshops, academic year follow-up programs, and attendance at arts events. Although the program benefits countless students and teachers from the region, it also provides a mechanism for arts faculty and graduate students to enrich and share their artistic and pedagogical skills. The program has been recognized by AASCU's Mitau Award and has received financial support from the National Endowment for the Arts and the Ohio Arts Council, among others.

The California State University

The California State University (CSU) comprises 19 campuses with a total enrollment of over 355,000 students and more than 20,000 full- and part-time faculty members. In addition to the teaching, research, and service of the individual campuses, the office of the chancellor provides funds and support for special programs for its constituencies, including special programs in the arts. Three of those programs are noted here. The CSU Summer Arts Program plays a major role in educating the artists, dancers, musicians, actors, designers, arts technicians, and other arts professionals who, in a few years, will shape the artistic world. It brings faculty and guest artists together as a team with university students to concentrate on a focused issue in 2-4-week segments of intensive working, learning, sharing, and growing in the arts. Summer Arts attempts to offer experiences that are not available on a single campus, so that there is expansion, not duplication, of campus efforts. Each year the program is de-

signed through a call for proposals from the faculty on the 19 campuses. All undergo a thorough review, and final approval rests with the host campus, which grants graduate and undergraduate credit. In addition to the opportunities for students, the local community is provided access to numerous public performances and exhibitions. Additionally, in conjunction with Summer Arts '88, a Visual and Performing Arts Staff Development Institute was offered. The institute centered on intensive, ongoing training in arts education for current California visual and performing arts classroom teachers, K-12. It focused on preparing these individuals to work as Visual and Performing Arts (VAPA) Teacher Trainers with the California Visual and Performing Arts Staff Development Center in affiliation with the State Department of Education. Another category of the Fine Arts Initiatives of CSU is campus programs in the arts funded by income from the California state lottery. These include Guest Artists/Artists in Residence, CSU Outstanding Faculty Artists Exchange, and Increasing Student Performance/Exhibition Opportunities. These initiatives greatly enrich the campus and community atmosphere. Finally, The California State University offers an Arts Faculty Institute to improve curriculum planning and instructional methodologies on all 19 campuses. All these efforts are enhanced by the formation of the Chancellor's Distinguished Artists Forum, consisting of outstanding artists who serve as resource persons to campuses and the chancellor's office, serve as models for students, and provide ongoing dialogue between practicing artists and CSU arts faculty and students.

California State Polytechnic University, Pomona

In 1966, California State Polytechnic University, Pomona was established as an independent institution from its parent institution Cal Poly, San Luis Obispo. The campus is one of the larger in the CSU system, with enrollments exceeding 18,000 students. The music program at Cal Poly Pomona is growing in a variety of ways. The number of student majors and general

student population enrollments have consistently increased over the last few years. In a further effort to meet the needs of Cal Poly Pomona students, the department is offering a new program in music business. Designed for students pursuing the Bachelor of Arts in music, the curriculum will be taught by professors from music, law, management and human relations, and accounting, augmented by visiting lecturers from the music industry. The program is designed to prepare students for careers in the recording industry and the publicity and management business. Further, the curriculum will help prepare young professionals who need to find and select producers, public relations specialists, merchandisers, managers, agents, editors, and other individuals who can help advance their careers. This practical education for musicians is a valuable addition to their musical training.

California State University, Dominguez Hills
 Located 10 miles from downtown Los Angeles, CSU, Dominguez Hills offers programs in the arts and sciences, education, and business administration. Its over 3,000 students reflect the cultural and ethnic diversity of Los Angeles. Among its many offerings in the arts is a graduate program in arts administration, designed to prepare current and future arts managers. The program supplies management tools in such areas as fund raising and development, marketing, financial management, and public relations. Its uniqueness, however, rests on its wedding of community service projects and administrative service internships to a strong theoretical and yet flexible understanding of organizational dynamics. During the course of study, students are involved in seven opportunities through which they are linked with arts organizations. Insight into management styles, philosophies of operations, community outreach, and artist direction are provided in living case studies. At the same time, small and medium-sized arts organizations receive needed assistance and documents such as budgets, fund-raising and marketing plans,

and grant proposals. The program stresses cultural and artistic diversity and seeks to prepare minority arts administrators.

California State University, Fresno

CSU, Fresno is located in the San Joaquin Valley of central California and serves a four-county region of close to a million citizens. As the only institution of its kind in the state's central region, the university is committed to developing its students into highly competent citizens and leaders and to serving its surrounding communities by providing a wide range of faculty expertise and physical facilities. The arts play a part in this dual mission. Over the past several years, the music department has been able to add several new internationally renowned faculty in both pedagogy and performance. Four give annual concerts abroad. As a result, the department is enrolling more students in its performance areas. In 1979, the department developed a unique student chamber music group, a scholarship woodwind quintet involving five talented freshmen who are to continue as a group until graduation. This performing ensemble, known as the President's Quintet because of the source of its funding, has been emulated by other departments across the country. The idea of having a student chamber group develop a fine sense of ensemble playing has proven successful. As a part of its performance opportunities, the President's Quintet regularly tours regional schools and cities, thereby enriching the musical experience for new audiences and serving as a model for musically interested young students. Other ensembles, faculty and student, also play for students and citizens who might not otherwise have the opportunity to attend live performances.

California State University, Long Beach

Located within the Greater Los Angeles/Long Beach metropolitan area and adjacent to the western section of Orange County, CSU, Long Beach is ideally situated in the midst of southern California's rapidly expanding visual and performing

arts activity. Consequently, there are excellent opportunities for the arts on campus to interact with arts organizations in the region. These opportunities include a ready availability of visiting artists and guest lecturers. At any given time, a multitude of exhibitions, performances, lectures, and other arts events take place within easy driving distance from the campus. These events are invaluable resources for students, and many faculty incorporate them into their course content. An additional cultural enrichment on the campus is the presence of students from 111 foreign countries, 46 states, and 3 territories, an older-than-usual student body, and many who are among the first in their families to attend college. Among the many fine programs in art, dance, design, music, and theater, two are particularly noteworthy. The art and design programs have for many years been recognized for their high quality. The curricula in design are professionally-oriented. The art department has a number of highly visible studio arts programs, especially painting, ceramics, and illustrations, including a highly regarded biomedical illustration certificate program. In addition, the department, in collaboration with the University Art Museum, offers a museum studies program. Another unique program is the Center for Educational Applications of Brain Hemisphere Research, locally known as the Brain Ed Center. The center relates research regarding brain hemisphere functions to questions of visual perception and human creativity. The center staff offers on-campus courses, and has offered courses, seminars, and workshops at many universities and for major corporations.

California State University, Los Angeles

CSU, Los Angeles (CSULA) was founded by the state legislature in 1947. Today, the institution is a comprehensive university that offers programs to 21,000 students in more than 50 academic and professional fields through six schools. With a student population that is 28 percent Hispanic, 29 percent Asian, 11 percent Black, 1 percent Native American, and 31 percent Cau-

casian, CSULA is one of the state's (and the nation's) most culturally rich and ethnically diverse campuses. The university has been designated as a focal point for the arts in the California State University system. With the rich cultural diversity of the campus and the community, and its location in one of the leading arts centers of the nation, CSULA has committed itself to becoming one of the leading universities in exploring multicultural arts. Several unique collaborative efforts—such as the Fine Arts Complex, the Los Angeles County High School for the Arts, the Joffrey Ballet, and the Pacific Rim Contemporary Music Center—are hallmarks of the burgeoning arts at CSULA. The Fine Arts Center, to be under construction in 1990 at a cost of $21 million, will house a 1,200 seat theater/auditorium, a "black box" theater, and a large art gallery. The buildings will be connected by a "Street of the Arts" and will reflect the arts of the diverse community. The facility has been named in honor of Harriet and Charles Luckman in recognition of their generous contribution of $2.1 million toward the facility; additional gifts have been received from the Ahmanson Foundation and the J. Paul Getty Trust. The complex is a joint partnership between the state and the private sector. Another aspect of the arts at CSULA is the Los Angeles County High School for the Arts. Begun in 1985, the high school now serves over 400 students who are selected in dance, music, theater, and visual arts. The presence of the high school on a university campus, and the collaborative efforts of the high school and the school of arts and letters in exhibitions and presentations, are both unique features of the high school.

Two other arts ventures greatly enrich the campus and community. In 1988, CSULA officially welcomed the Joffrey Ballet as the university's dance company in residence. The Joffrey is provided with rehearsal space, offices, and living accommodations on campus; in return, the ballet company provides master classes, workshops, seminars, and performances for students enrolled at the university, the LA County High School for the Arts, and other CSU campuses. Additionally, CSULA has

recently formed the Pacific Contemporary Music Center (PCMC). The center is designed to be a catalyst for breaking national and cultural barriers and merging musical traditions that have been isolated throughout their histories. Through the PCMC library, seminars, and other exchanges, the 160 members of the PCMC promote and encourage performance and study of a wide range of national, contemporary musical styles. Roughly 60 percent of the membership is from the United States; the balance is located throughout the Pacific Rim.

California State University, Northridge

CSU, Northridge is a liberal arts institution that also has substantial programs in professional and technological fields. Located in the western section of the San Fernando Valley, the university enrolls approximately 30,000 students in its eight schools. The school of the arts consists of six departments: art general studies, art history, art three-dimensional media, art two-dimensional media, music, and theater. The school seeks to enrich the community and local elementary and secondary schools of the region. One such example is the theater department's school outreach program, a two-tiered program. One tier consists of the Experimental Theatre group, which in addition to a normal production schedule produces 10 school-day matinees. Middle and high school students are bused to these productions. Fall productions are generally drawn from the modern classic repertoire, while spring productions are taken from a broader range of classics. The second tier is the Elementary School Touring Theatre Program. University students develop tour programs designed for elementary school audiences, such as folk tales in the story theater format. Twice a week for five weeks during the semester, the ensemble goes to elementary schools for presentations. These twin efforts raise the cultural awareness of many students and, most important, reach culturally and underserved audiences, providing children and young adults with arts experiences that might otherwise be unavailable to them.

Cameron University (OK)

Cameron University enrolls over 6,000 students. Through its undergraduate and graduate programs, guided by faculty in seven schools, the university seeks to meet the educational needs of the 100,000 people living in the Lawton/Fort Sill area. One of those schools, fine arts, recognizes the societal necessity for college graduates with a broad liberal education and the ability to compose, create, and conceptualize. These demands conflict with many of the present nationwide curricula with heavy concentration in the major disciplines. Instead, Cameron University has been developing an innovative program designed to provide students with an integrated fine arts core that encompasses the five traditional fine arts disciplines of art, communication, music, theater, and dance. Over the past nine years, the school of fine arts has constructed a $6-million fine arts center, integrated the fine arts departments into a school, created separate professional and liberal arts degrees, developed an interschool major, and established interdisciplinary requirements for fine arts majors. One successful area of integration is activity requirements of the departments; students are required to participate in activities in all departments. A second area of integration is on the stage, in which art, theater, music, and communications students collaborate. A third element is an integrated core curriculum for all majors in the traditional disciplines. A one-year, two course, team-taught sequence will replace the 10 freshman-level introductory courses. This sequence is intended to enhance the students' unique perspectives in their areas of concentration and enable them to gain a greater appreciation of their chosen field in relation to the other fine arts, and is intended to lead students to greater creative thinking and higher value judgments in all fields.

Central Connecticut State University

Central Connecticut State University (CCSU), founded in 1849, is the state's oldest public institution of higher learning. The campus is centrally located in New Britain. To enhance its

curricular offerings and enrich the community, the university has completed a new fine arts center. It houses the art and theater departments and has facilities for instruction, performance, and exhibition. The center provides the art department with increased and improved space for extant programs in art history, painting, sculpture, ceramics, and art education. It enables the department to undertake new initiatives in graphic design, illustration, photography, and printmaking. The fine arts center gallery/museum, with over 3,000 square feet of space, presents invitational exhibitions, lectures, community outreach programs, and other special events honoring Connecticut arts and artists. The theater facilities of the center include one of the best-equipped, flexible experimental stages in the region. Scene and costume shops and studio classrooms enhance the performance area, providing space for extensive and intensive training in movement, voice, acting, directing, design, and technical arts and crafts of the theater. Among CCSU's successful programs is its summer music series, which provides continuing education for music educators at the elementary and secondary levels. It consists of some 35 one- and two-week workshops covering a wide array of subjects, including conducting, instrument repair, curriculum construction, computers, and special needs music teaching. Approximately 400 teachers attend the workshops from some 32 states and Japan. This opportunity to enhance their skills is valuable to the teachers and, ultimately, their students.

Central Michigan University

Central Michigan University (CMU) is an institution of some 17,000 students and is located in the middle of the state. In recent decades, CMU has moved away from its historic identity as an institution devoted primarily to teacher education and has become a university serving students with a broad range of programs. CMU draws students from throughout the state and elsewhere. It also serves a broad geographic region with its public

television and radio stations, covering the northern half of the lower peninsula, a major portion of the upper peninsula, and a significant section of northwestern Ontario. CMU provides a focus for activities in the arts for much of the northern half of the state. One program in the arts that has particular potential to benefit both Michigan and CMU is the relatively new Petoskey Summer Theatre Project, begun in 1987. In this program, a summer theater company of 12 CMU students mount three complete productions to be performed in the city of Petoskey, Michigan, during the final three weeks of the eight-week term. The first five weeks are devoted to rehearsals, set construction, and other production work. The interaction of Central Michigan and the Petoskey/Harbor Springs/Charlevoix area is a positive experience for both. CMU benefits from the visibility for its excellent theater program; the activity enhances the area's growing reputation as a summer arts colony.

Central Missouri State University

Central Missouri State University is located in Warrensburg, a town of over 13,000 located 50 miles southeast of Kansas City. It serves some 8,500 undergraduate and graduate students in a variety of disciplines. The art department, a unit of the college of arts and sciences, offers programs in commercial art, interior design, studio art, art history, and art education. The design programs prepare students to meet the requirements of a commerce-oriented society. A balance between "client"-directed design projects and the developmental needs of young artists is maintained. The focus is on art for communicative functioning and for enhancing the quality of the visual environment. The more traditional programs of studio art, art history, and art education are designed to produce artists and scholars who are well-grounded in their disciplines and well-developed in their artistic, scholarly, and teaching skills. Because the Warrensburg area population is diverse in background and socioeconomic conditions, the art department provides programs sufficiently

81

diverse to help students from the area realize their potential and achieve their goals, leave the area for distant challenges, or return home to develop native resources into an indigenous form of art. The art department sees as part of its overall responsibility the generation and continuation of cultural growth on campus for its major and the non-arts students and for the broader regional community.

Central State University (OK)

Central State University (CSU) was established as the first institution of higher learning in Oklahoma. Located in Edmund, the university enrolls over 14,000 students. The arts programs include art, music, creative studies, dance, radio, television, and theater. In addition to its regular curricular offerings, each program includes specific projects and events. For example, students develop advertising design work for community non-profit organizations and for community cultural events. Other students help plan, implement, and jury special art projects and exhibits at the Oklahoma Arts Center. CSU seeks to reach beyond its campus through its art museum's traveling exhibits and loan programs, through its radio and television offerings, and through a special program entitled "Sundays at Central"—presentations with a distinct theme for faculty, students, and local citizens.

Christopher Newport College (VA)

Christopher Newport College is a four-year, nonresidential, urban college offering undergraduate programs designed to serve 4,400 students and the large metropolitan area of Newport News, Hampton, and several surrounding counties. Building its programs on a substantial core of liberal arts studies, the college is committed to education as a total-community process. This leads to the use of the community as an instructional resource and to the college's providing educational and cultural experiences for the students and the entire community. One of the special ways that the college works with local public schools is through the

"Summer Institute for the Arts." This yearly institute consists of six weeks of classes in art, dance, music, and theater. Approximately 100 high school students are admitted by audition/ portfolio. On successful completion of the program, a student is awarded one high school credit by the local schools. In another effort to broadly educate college students, who range in age from high school enrichment students to senior citizens, the college offers several courses that introduce the various art forms.

Coastal Carolina College of the University of South Carolina
USC Coastal Carolina College offers liberal arts and teacher education programs to some 2,500 students. It also serves as the cultural center of the rapidly growing Myrtle Beach and Grand Strand area of South Carolina. Cultural arts programs are offered to the campus and the community under the umbrella of the Wheelwright Council for the Arts. The council, consisting of college administrators, faculty, and community supporters of the arts, coordinates an annual subscription series called the Wheelwright Passport. The Passport features a film series, a college theater series, a cultural arts series, a lecture series, and a Wheelwright Council series. The Coastal Film Series offers seven films on Sundays throughout the academic year; classic films as alternatives to current popular media. The theater series presents four student/faculty plays each year. The cultural arts series, consisting of professional musicians, actors, touring companies, and exhibitions, presents five events per year. This series is supported in part by student activity fees, grants from state and national agencies, and donations to the college foundation. The Kimbel Lecture Series brings prominent speakers to the campus in the areas of government, media, and performing arts. The Wheelwright Council Series brings operas, ballets, and symphony orchestras to the campus and community. These larger scaled events are primarily funded by grants and donations from community sponsors. Through continued cooperation between the college and the community, the Wheelwright Council

for the Arts hopes to expand its programming and attract capacity audiences.

East Texas State University

East Texas State University (ETSU), located in Commerce in the northeastern Texas countryside, serves the needs of approximately 7,000 students. With one of the highest average ACT scores among entering freshmen of any state university in Texas, the university seeks excellence through its programs in three undergraduate colleges and its graduate school. The art department at ETSU has spacious and modern facilities, and a unique feature is the availability of two specially equipped dormitories for art students that provide studio space in the living quarters. A noteworthy program is the Communication Arts Program, formerly called "Advertising Art." While working on a B.A., B.S., or B.F.A. degree, the student can choose a professional emphasis in design communications, illustration, art direction, or copywriting. The only university in its region with so many communication arts options, ETSU has one of the few art direction programs, and the first copywriting program, in the United States. Each option is tailored to meet the individual professional goals and abilities of the student. All courses in this area are taught by the most accomplished professionals available in the fields. All of these instructors are directly involved in state-of-the-art methods in their given fields, and each instructor serves as a direct link with the advertising agency and its network in the immediate area. Advanced course credit for internships in major Dallas ad agencies are common. The communication arts program features a unique In-House Agency, an actual assimilation of an inner-city ad agency, and is composed of advanced students from the various professional roles typically interacting in a comparable real-world situation. As a result of these efforts, students have won numerous awards, have secured substantial employment in key agencies, and have contributed to the aesthetics of communication arts in the nation.

Eastern Illinois University

Located in Charleston (population 20,000), Eastern Illinois University (EIU) is a residential, comprehensive university offering education in the liberal arts and sciences and professions. The primary hallmark of the college of fine arts is teacher education. The college enjoys a reputation for its teacher education programs and for the success of its teacher graduates. The college sees its specific goal as the development of highly talented performing and creative artists who are prepared for professional career in the arts and arts education. Thus, the college provides an academic base in history, theory, composition, and performance/exhibition, and builds programs in such areas as computer graphics, merchandising, recording technology, teaching, and technical assistance. An event that unites all of the college's units with the larger community is "Celebration: A Festival of the Arts." Celebration has been an annual event at EIU since 1977. Originally funded in part by a grant from the National Endowment for the Arts that focused on the collection of indigenous folk music and art in central and southern Illinois, the event has grown to become what is described as a "smorgasbord of the arts." The campus concert, exhibition, and outdoor spaces are fully utilized to showcase the folk arts of Illinois and to expand audience appreciation, identification, and awareness through active observance of similarities and differences between Illinois folk culture and those of other cultures. Designed to spotlight local, indigenous arts as well as to introduce arts that are not readily accessible to the East Central Illinois population, the festival is continually growing, lively, and educational. Supported by EIU, the state arts and humanities councils, and private-sector funds, the festival attracts some 20,000 students, faculty, and regional citizens.

Eastern Kentucky University

Eastern Kentucky University, which began in 1906 as a state normal school, achieved university status in 1966. Today,

it offers programs to over 11,000 students in the colleges of applied health and nursing, applied arts and technology, arts and humanities, business, education, health/physical education/ recreation/athletics, law enforcement, natural and mathematical sciences, social and behavioral sciences, and the graduate school. In an effort to expand professional opportunities for its students and graduates, the college of arts and humanities has recently instituted two degree programs: the Bachelor of Fine Arts in the Performing Arts and the Bachelor of Arts in Music Merchandising. The performing arts degree is designed to prepare students for a career in musical theater. Jointly administered by the department of music and the department of speech and theater arts, the program includes courses in music, drama, dance, and musical theater productions. Summer experience in theme parks, cruise ships, and community theater is encouraged. The music merchandising degree is for students who wish to pursue a career in the music industry, such as music publishing, wholesale and retail enterprises, marketing, and management of music firms. The curriculum consists of 27 credit hours of business instruction, a core of music courses ranging from music theory to applied music ensemble participation, and specialized courses in music merchandising. An internship program is a part of the offerings in this degree.

Eastern Michigan University

Eastern Michigan University (EMU), located in Ypsilanti, was founded in 1849 as a normal school. Today, it offers programs to over 11,000 undergraduates and nearly 7,000 graduates in the areas of arts, sciences, business, education, health, human services, and technology. Since 1965, when the need for more and better-trained art administrators was identified by the Rockefeller Foundation, there has been growing national recognition of this area. The newest, and perhaps most innovative, program in the arts at EMU is the interdisciplinary major in arts management, offered at both the undergraduate

and graduate levels. There are only four institutions in Michigan that offer an arts management emphasis; the curriculum at EMU is the only one of the four that requires coursework in the college of business as well as in the college of arts and sciences. The program also includes an on- or off-campus internship in arts management. A second EMU program that has proven to be successful and influential is the McAndless Distinguished Professor Chair in the Humanities. The appointment is reserved for persons of national or international reputation in the various areas of the humanities. The Distinguished Professor is expected, for one year, to teach one course, give one or more public lectures, and give one or more seminars for faculty. Maxine Hong Kingston, contemporary American writer, was the first person honored through the endowed chair. Distinguished Professor Richard Hunt, internationally respected sculptor, was so honored by the department of art.

Eastern New Mexico University

Eastern New Mexico University (ENMU) serves two states and eight counties—a geographical area equivalent to the combined states of Rhode Island, Massachusetts, and New Jersey. The ENMU enrollment is 4,000. The ENMU school of music offers a number of degrees, including one in music therapy—the only one in the state. The theater program at the university will be enhanced by a new center, a $4.5 million project that will be completed in 1990. The facility will feature a 420-seat proscenium theater with a fly loft and a modified thrust, an experimental theater, classrooms, scene and costume shops, and academic offices. The ENMU art department has doubled its enrollment in the last four years, resulting in large part from its graphic design program, which features state-of-the-art computer graphics systems. The program combines the fundamental skills that a successful graphic designer needs with the latest technology. For example, students have access to a Genegraphics Computer Graphics System, which places over 16 million colors at the

students' disposal, with unlimited brush strokes, thus providing almost limitless artistic possibilities. The system has been placed "on line" in the facilities of KENW-TV, a PBS affiliate located on the campus, so that students may learn television graphics and produce commercial art projects.

Framingham State College (MA)

Framingham State College (FSC) is a liberal arts college serving approximately 3,000 students in 28 undergraduate and 15 master's programs. The college is located 20 miles west of downtown Boston, an area rich in cultural and artistic activities that are open and accessible to the college community. The arts at FSC are found in three deparments: art, media communications, and music. Majors are offered in art history, studio art, and communications, with a minor offered in music. In addition to its academic programs in the arts, FSC supports the arts for its students and the commmunity through three important projects. In 1975, the Danforth Art Museum was established through a cooperative venture between the college and the community. The museum has six large galleries, a museum school for the general public, and a lecture hall. The museum, which still receives substantial annual financial support from the college, sponsors special and permanent exhibitions, an international film program, a school subscription service with slide/lecture presentations and curricula, and a museum internship program for college students. A second collaborative effort of the college is with the New England Philharmonic Orchestra, which since 1986 has been the orchestra-in-residence at the college. The orchestra presents a concert season, several chamber performances, and a youth concert competition, all for students and the general public. Finally, the Framingham State College Arts and Humanities Program was initiated in 1986. The purpose of the program is "to enrich the total college community by establishing a broadbased variety of programs that will give ... the opportunity to see, hear, and meet prominent artists, authors, entertainers, histori-

ans, philosophers, politicians, and scientists, or their works." In 1987-88, 41 events were offered to students and the public, including presentations by Maya Angelou, Toni Morrison, Dith Pran, Ralph Nader, and Jane Brody. The program is primarily supported by student fees, vote-approved by the student government, and from other gifts and grants. These three college/community collaborations indicate ways in which the college seeks to expand and enrich arts offerings for the students and the public.

Frostburg State University (MD)

Frostburg State University (FSU) lies in a sparce cultural setting in Appalachian Maryland. Having grown to over 4,000 students, the university is taking its regional influence seriously, in the arts and in other areas. FSU has faculty in art, music, theater, dance, and creative writing. These faculty members teach courses in their major fields, offer service courses to nonmajors, and participate in outreach efforts. Without attempting to dominate the region, the university has taken an active role in improving its cultural climate. For example, FSU participates in a regional alliance of artists and arts producers, coordinating scheduling, promoting, and fund raising. It has played a vital role in the creation of a new summer theater in downtown Cumberland. It participates in the planning and implementation for the international whitewater competitions. FSU brings numerous arts events to this campus each summer, such as the Western Maryland Writers Workshop, a music camp, master classes, exhibitions, and the like.

George Mason University (VA)

George Mason University (GMU) is a fast-growing institution in Fairfax County, approximately 25 miles west of Washington, D.C. Initially set in a rural area, it is now in the midst of a burgeoning urban development. Its 17,000 students are largely commuters. GMU has determined to become the arts center of

northern Virginia. It is completing an arts center, which will provide instructional space for art, music, dance, and theater, as well as performance and exhibition space for the campus and community. Examples of outreach include the Fairfax County Music Festival, which consists of all-county band, orchestra, and chorus. In addition to individual performances by these groups, works utilizing large resources complete the programming. In one festival, *Prologue to Mephistopholes* by Boito was performed by two 700 antiphonal high school choruses, a 500-voice intermediate school chorus, a 150-piece orchestra, and four antiphonal brass groups. This provides unique musical experiences for the students and the audience. GMU also offers an International Arts Festival, which brings top-quality performances from around the world. GMU's artist series greatly enriches the campus and the region. With its new arts center and its present 10,000-seat Patriot Center, GMU will continue to offer a wide range of performances and exhibitions for the citizens of northern Virginia.

Georgia College

Georgia College, a senior college in the University System of Georgia, currently serves 4,500 students in middle Georgia. Long known for its emphasis on teacher education, Georgia College has shown steady growth in recent years in all programs, including teacher education, business, traditional programs in arts and sciences, and off-campus programs. The faculty has sought to bridge the gaps between academic disciplines by making efforts to demonstrate that all disciplines can address issues of common concern from different directions and methodologies. Among these efforts has been a college-community forum in which members of the departments of art and chemistry discussed ethical questions associated with art, technology, medicine, and other areas. The college has now established an annual "Day for Arts and Sciences," sponsored by Georgia College and the school of arts and sciences. The first "day" included a look into the future

from the perspective of scientists, political scientists, artists, and other faculty. Another "day" involved a look at the environmental crisis, again from several perspectives. Through these cross-disciplinary efforts, and the more traditional arts offerings of the campus, the arts on a small campus, for a small town, are thriving.

Georgia Southern College

Georgia Southern College (GSC) is the fastest-growing senior college in the state and one of the fastest-growing in the nation, with enrollment increases of 6 percent, 10 percent, and 15 percent in the last three years. The college is located in Statesboro, a community of some 20,000 people, and has as its service area a large portion of rural southeastern Georgia. Georgia, like many southeastern states, has a level of educational attainment that is lower than the national norm; the level for southern Georgia is lower than that of the rest of the state. Furthermore, because of the rural nature of the region, opportunities for exposure to the arts are limited. Many of GSC's students are first-generation college students who have had few experiences in the arts during their formative years. For these reasons, GSC's programming in the arts encompasses outreach. It is part of its mission to take the arts to surrounding communities, especially to elementary and secondary schools, to introduce people to the arts, and to begin some education in the arts. Toward that end, the college has secured funds from various sources and developed college/community arts efforts, including an Artists-in-the-Schools program that features in-school residencies of Georgia artists, thus encouraging an awareness of "local" talent. Further, longer-term schools residencies are developed by local schools, and GSC utilizes these resident talents in recitals or exhibitions. The college and local regional library sponsor a visit by one of three touring visual arts educational exhibitions developed by the Georgia Council for the Arts' Art Bus Program. Detailed resource materials are provided for teachers, docents, and students who

visit the exhibit. Typically 3,700 students and some 500 adults view the exhibits during the 2-1/2-week visit. The college sponsors the Poster Project, in which college art students design a large promotional poster whose center section is left blank. A local sponsor prints 6,000 of these posters; children from first grade through college can fill in the space with their creative ideas and skills. These completed posters are displayed throughout the county from supermarket windows to refrigerator doors to advertise the annual culmination of three months of activity, the Youth Arts Festival. On the campus, several thousand teachers, students, parents, children, artists, and performers celebrate the arts during the festival. This celebration includes art production, performances, exhibitions, and creative games. The presentations are by elementary students through professional artists. This annual celebration is a unique undertaking for a rural community in southeastern Georgia. One important sign of the success of these ventures is that local schools have hired full-time teachers in the arts where there were none in the past.

Governors State University (IL)

Located 35 south of the Chicago Loop, Governors State is an upper-division, master's-level university serving as a capstone to five community colleges in its immediate service region. There are no dormitories on campus; the 5,500 students commute from within a radius of 35 miles. Over 85 percent of GSU's 11,000 graduates still reside within the region. GSU serves its region and is an active, working partner in its economic, cultural, educational, and social progress. Toward this end, GSU is conducting a $5.4-million capital campaign to build a regional center for the performing arts. The center will include a 900-seat, fully equipped theater. One feature of the theater will be seven strategically placed television camera stations, allowing the theater to serve south metropolitan Chicago's needs in continuing education and in ground and satellite telecommunications, as well as the performing arts. The two-way satellite video conferencing will

make the center unique in the Chicago area. The State of Illinois legislature, for the first time ever, has challenged one of its university foundations by offering $3,800,000 in matching funds; the university is to secure the balance. The campaign is nearing completion.

Henderson State University (AR)

Henderson is a small university in rural southwestern Arkansas. The nearest metropolitan center, Little Rock, is 65 miles away; therefore, it is incumbent on Henderson to offer cultural events to its community and region. The primary function of the school of fine arts is arts education—for teachers, practitioners, and consumers of the fine arts. In addressing this mission, the university provides a full schedule of concerts, performances, and exhibitions to its students and the public. In addition to these offerings, the university hosts the Arkansas Art Exhibit, in which noted national artists are in residence and awards are given to Arkansas artists. Their works then tour local schools and community centers. Other arts outreach programs include faculty concerts, touring music groups, and dance performances. University students are enriched through organized cultural tours to New York, London, and elsewhere.

Humboldt State University (CA)

Humboldt State University (HSU), one of the 19 campuses of the California State University system, is located 275 miles north of San Francisco in the redwoods country. It serves some 6,500 undergraduate and graduate students in a wide range of academic disciplines. Creative arts and humanities are an important element of the campus atmosphere and enrich the rural region. Among the important aspects of HSU's arts activities has been its role as host of the California State University Summer Arts Program for college students (see the California State University). This is a significant project for the state; the rural "retreat" atmosphere for HSU lends itself to intensive creative work.

Another interesting aspect of arts offerings at HSU is the long-time commitment of the theater department to the production of new plays. In alternate years, entire seasons are made up of new plays selected from a national competition. The playwrights visit the campus for 2-4 weeks to work with students, participate in rewrites, and in general to take a full role in the productions. These seasons have a significant effect on new works as well as on the education of students in contemporary theater.

Illinois State University

Illinois State University is located in Normal, approximately 140 miles south of Chicago. Some 23,000 students are enrolled, most of them full-time undergraduates. Of the five colleges in the university, the college of fine arts is the youngest (approximately 20 years old) and the smallest, with some 1,000 majors and 120 faculty members. Its three departments (art, music, and theater) have two primary missions: (1) to prepare professional teachers of the arts and professional artists and (2) to provide a cultural environment for students and people from the community and region.

Toward the former goal, the college attempts to keep abreast of modern technology and the impact it may have on arts production. Computers have become an important tool in art production. Over the past several years, the college of fine arts has developed one of the most recognized microcomputer arts labs in the midwest. The Office of Research in Arts Technology (ORAT) functions in the college as an administrative umbrella for supervising all computer operations with the departments of art, music, theater, and the college office. ORAT operates the college of fine arts' microcomputer laboratory and its satellite stations (weaving studio, theater CAD system, and theater box office), supervises faculty and student computer activities, maintains a curricululm of five microcomputer-in-the-arts courses and summer courses, sponsors an internship program with local schools and industry, oversees public relations activities for the

college computer program, and supervises maintenance and repair of all computer equipment in the college. This lab attracts computer arts specialists from throughout America to workshops, while other universities do regular consultation in their efforts to establish similar systems.

To address the second part of its mission, the college provides a full array of performances and exhibitions for the campus and community. One of the more popular events is the Illinois Shakespeare Festival, which produces three plays each season, featuring artists recruited from throughout America. Finally, nonmajors are encouraged to participate in the arts through classes and projects. One such class is called "Aesthetic Experiences," through which one hour of credit is available on a credit/no credit basis for attendance at 15 fine arts events and the writing of three reports. The purpose of this course is to acquaint students with the visual and performing arts opportunities on campus and, thus, to encourage a greater participation in cultural events in their future lives.

Indiana State University

Indiana State's (ISU) main campus adjoins the north side of Terre Haute's downtown business district. At this and other sites, ISU offers programs to some 11,000 students in the areas of arts, sciences, business, education, health and physical education, recreation, nursing, and technology. The arts play an important role in the life of the campus and the community. One unique feature of the arts at ISU is the summer theater program, Summer Stage. Summer Stage is an effective means for introducing students to the processes and personnel of a professional theater operation, for offering high-quality, up-to-the-moment theater programming for the university's constituents, for providing an important cultural link between the university and the community, and for introducing new works to the American theater. Each year Summer Stage, in a six-week season, presents four productions in revolving repertory in an intimate, flexible theater

and a cabaret in the local civic center. The company consists of 2-3 Equity Guest Artists, 3-5 non-Equity professional actors, and 3-6 advanced student actors. The university employs outside professional directors, designers, and technicians as well as faculty members. Students are employed as actors and technicians. An important aspect of the program is that actors, designers, and technicians are able to participate in the development of new plays; the entire company is involved in the total process of theater from the writing through the final production. Two plays that were developed and first produced at Summer Stage have been published and professionally produced elsewhere. Other plays have had staged readings and productions at such theaters as Berkeley Repertory Company, Actor's Theatre of Louisville, and off-Broadway in New York. Central to the summer theater is the strong interrelationship with the university's academic program. The Summer Stage provides professional experience to students while enriching the region with good theater.

Indiana University Northwest

Located in Gary, the northwestern campus of Indiana University began baccalaureate degrees in the 1960s. It became a separate institution in the Indiana University system in 1968. It offers programs to nearly 3,000 in arts, sciences, business, education, health professions, and urban issues. A major aspect of IUN's Outreach Art Program is the Gallery Northwest. Located in northwest Indiana, it provides excellent opportunities for acquiring a variety of art from regional artists as well as Chicago area artists. It also attracts a number of traveling shows. For example, a successful endeavor was the exhibit of art from the Sichuan Fine Arts Institute from The People's Republic of China. This exhibition consisted of over 50 prints created by 20 of the institute's finest students and was viewed by hundreds of students and area citizens. The gallery will continue to present a blend of regional art and international art to its constituents.

Jackson State University (MS)

Jackson State University (JSU) is a coeducational institution of higher learning located in Jackson, the capital city and cultural center of Mississippi. The university offers undergraduate programs to just over 7,000 students in the areas of business, education, industrial and technical studies, and liberal studies. The university's historical commitment to excellence in the arts is enhanced by a vast array of outstanding programs and activities, including Lyceum programs, the President's Concert Series, dramatic productions, operatic performances, art exhibitions, and student, faculty, and guest artist recitals. Music is a prime ingredient in JSU's cultural development of the state. JSU has an ongoing sponsorship of *Opera/South,* the only professional opera company whose operations are university-based. The university also has the largest orchestra on a campus of Historically Black Public Colleges and Universities. Its choir won the American Negro Spiritual Festival in 1986 and toured Germany and Austria this past year. Reaching into the community, JSU offers the Gladys P. Norris Piano Festival for students of all ages, the Annual Church Music Workshop, which attracts people from 17 states, and the Annual High School Jazz Festival, a regional qualifying festival for *down beat* magazine's MusicFest U.S.A.

Kean College of New Jersey

Kean College is a state-supported liberal arts college on a suburban campus 25 from New York City. The proximity of the college to one of the most artistically active areas in the world provides both students and faculty with exceptional opportunities for artistic and cultural enrichment. Additionally, there has been significant development in the arts in suburban New Jersey. The college has become home to several major professional arts organizations, such as the New Jersey Ballet Company and the Garden State Chamber Orchestra. The artistic and cutural programming provided by the college has placed it at the center

of the artistic and cultural life of the community. The fine and performing arts at Kean College are designed to serve the needs of students who major in those areas and to provide the major resource for the general education of all students. Majors in the art, music, communications and theater study curricula are firmly grounded in the liberal arts but also have specific career components, including cooperative education opportunities. Nonmajors must take upwards of 50 percent of their total curriculum in the liberal arts. The new general education core curriculum also features an interdisciplinary core course, "Intellectual and Cultural Traditions," which places heavy emphasis on the fine and performing arts. There is an increased demand for arts courses for the nonmajors and rising student interest in those areas.

Keene State College (NH)

Keene State College (KSC) offers undergraduate and graduate education to over 3,100 students in the arts, sciences, professional studies, and continuing education. The fine and performing arts serve as a window for the college, a window through which the community, state, and region see some of the best of what the college has to offer. In addition to academic programs in art, music, and theater arts, speech and film (including dance), the college enriches the region through a variety of endeavors. Student, professional, and community performances are offered at the Arts Center on Brickyard Pond. The center consists of the main theater, recital hall, studio "blackbox" theater, and the Putnam Arts Lecture Hall. This latter facility is equipped with 70-millimeter projection capabilities and six-track, state-of-the-art, Dolby stereo sound. Keene State is one of only seven colleges in the country with this elaborate equipment, enabling it to offer a substantial film series. Additionally, the Thorne-Sagendorph Art Gallery exhibits local, regional, national, and international shows throughout the year. The Apple Hill Chamber Players, artists in residence at the college,

provide four concerts per year, conduct master classes for KSC students, give performances in area schools, and tour throughout the world, representing the college and the state.

Kennesaw State College (GA)

Kennesaw State College is a four-year institution offering undergraduate and graduate majors to over 8,000 students. This year, Kennesaw celebrates its 25th Jubilee Anniversary. A commuter school located in the northwest section of metropolitan Atlanta, Kennesaw has doubled its enrollment and increased the number of major programs since 1980. The college offers degrees in visual arts, art education, music, and music education. To meet the ever-growing need for additional arts facilities, the college has made several recent expansions, including a classroom building and performing arts center that will open in Fall 1989. This building, adjacent to the department of music, will have a 300-seat auditorium for music and theater presentations. The auditorium will be fully equipped with an orchestra pit, wings and a fly loft for productions. Rehearsal space for drama, dance, and music will be provided, as well as a small art gallery in the foyer. In addition to greatly improving instructional capabilities for students, these facilities will greatly enhance Kennesaw's efforts at community outreach. As a part of the dedication festivities for the new Performing Arts Theater, the Kennesaw State Opera Omnia will present "Cole," a musical review of the works of Cole Porter, to be followed by Thorton Wilder's "Our Town" and other productions.

Kentucky State University

Kentucky State University is primarily a baccalaureate degree-granting institution situated in Frankfort, the capital of Kentucky, and surrounded by an agrarian environment. The university's population of approximately 2,100 students and 116 faculty members is the most integrated of the state institutions of public higher education. In response to its new mission "to be the

state's unique, small institution of liberal studies," the university developed and implemented an integrated fine arts major. This major fuses the separate programs of art, music, and theater to give students a broad-based, holistic education in the arts. Business and marketing courses in the arts are a part of the major. Through team-taught courses, the students participate in integrated arts activities and productions. The primary objective of the program is to prepare students to function effectively in settings that require comprehensive knowledge and skills in the arts, such as state arts agencies, community arts centers, and vacation, recreation, and retirement areas that emphasize the arts.

Lake Superior State University (MI)

Lake Superior State University University is the cultural focal point for the Eastern Upper Peninsula, a remote and isolated environment for some 28,000 people in an area of 2,520 square miles. The university, though it offers programs that prepare some 2,900 students for the work place, emphasizes the importance of a broad-based education. Toward this end, the curricula require all students to take courses in general education (a core curriculum in the arts and sciences), electives, and required courses for specific majors. Of the 186 hours now required for an undergraduate degree, better than half are in areas other than a major content area of study. The institution asserts that the fine and performing arts present unique opportunities for students to acquire "educational breadth, a depth of values and flexibility." These offerings include materials and ideas from the fine and performing arts and take the form of lecture, laboratory, and participatory courses. They seek to clarify, for all students, the perspectives that creative artists have brought to bear on human beings and their endeavors.

Lamar University (TX)

Lamar University developed from a community college pro-

gram initiated by the residents of Beaumont in 1923. Its original name, Lamar Technological University, reflects the motivation for the creation of such an institution—the technological atmosphere of the petrochemical industry characteristic of the region. Within this framework, growth of the arts programs on the campus was often slow and difficult. But an enlightened administration and an arts-interested community eventually provided for the creation of a college of fine arts and the develoment of full academic programs in the visual arts, dance, music, and theater. One element that aided the fine arts programs in their expansion and enhanced quality was the formation of the Lamar University Friends of the Arts in 1972. This organization has a self-perpetuating board of directors that meets regularly throughout the year and maintains a strong interest in the arts programs of the institution, particularly by developing and encouraging community support. The Friends organization has raised approximately $800,000 over the years; it is also largely responsible for the construction of a $1.2-million, 10,000-square-foot art gallery on the campus. Friends' funds have also been used to supplement budget funds from the State of Texas. Expenditures include additional student scholarships; travel funds for faculty and students to attend clinics, seminars, workshops, and competitions; support for visiting artists; additional equipment; and arts works for the permanent collection.

Lincoln University (PA)

Lincoln University is an internationally oriented, state related university of liberal arts. Founded in 1854, it is the oldest college in the United States to be originally formed to provide higher education to Black youth. It serves some 1,000 students through programs in the humanities, natural sciences, and social sciences. The university offers curricular and extracurricular opportunities in music, art, theater, and dance to students and the community. One such example is the Lincoln University Dance Troupe, founded in 1968 as a voluntary, student organi-

zation to give students who were not dance majors an opportunity to focus their dance energies on creative movements. The troupe has performed regionally at hospitals, rehabilitation centers, churches, schools, and universities. It has been recognized and commended by the Pennsylvania Legislative Black Caucus and the National Recreation and Parks Ethnic Minority Society, among others. The students have sponsored workshops with National Dance Theatre from Zaire, Katherine Dunham, Pearl Primus, Rod Rogers, Arthur Hall, and others. The troupe has sponsored seminars for the community on the contribution of Blacks to music and dance. They have performed at the American College Theatre Festival, at state and national meetings, and have hosted the Annual Black College Dance Exchange.

Louisiana Tech University

Louisiana Tech University (LTU), located in Ruston, is some 70 miles east of Shreveport. It enrolls some 11,000 students, 4,500 of whom reside in residence halls. The arts are an important part of the life of the campus and the community. One unique program, in which the arts are prominent, is the summer study program in Italy. For six weeks of each summer since 1969, faculty and students have studied and traveled in Italy's rich cultural and artistic setting. Housed in LTU's permanent facilities in the heart of Rome, over 50 courses are offered by LTU's faculty. In addition to these graduate and undergraduate offerings, the group travels throughout Italy and offers optional trips to Greece, France, and Switzerland. Students' cultural horizons are greatly broadened by the opportunity to live and study in this historic center of western civilization and to be exposed to contemporary European cultural values.

Lyndon State College (VT)

Lyndon State College is a small university located in rural northeastern Vermont. The college of fewer than 900 undergraduates offers liberal arts, teacher education, and preprofes-

sional education. Programs in the arts are limited to a B.A. in visual design and a B.S. in television performance and writing and television production. The college offers courses in art and music, without degree programs. Lyndon's library and theater make the college a regional center for cultural events, many programmed by external organizations. It includes a gallery for use by local artists and visiting exhibitions. Lyndon's communications programs serve approximately 15 percent of its degree enrollment. The curriculum is heavily oriented toward studio performance, whether in graphic design or in producing videotape of news and feature events. Thus, the studio and student interns have made the college a regional communications center. In addition to university funds, the programs are augmented by other state and federal funds.

Marshall University (WV)

Located near the heart of downtown Huntington, Marshall University offers a broad academic program to its 12,000 students. Its urban location and its emphasis on programs serving older working persons as well as the traditional college age group are reflected in its currently growing enrollment, 89 percent of which is composed of West Virginia residents. Marshall employs more than 450 faculty members in 10 colleges and schools. The college of fine arts offers degrees in music, theater, and visual arts. The college provides many curricular and outreach programs. Two examples demonstrate the commitment of the college to scholarship and service. From its beginning in 1937 as part of the Centennial observance of Marshall College, the Marshall Artist Series has grown to be one of the most prestigious campus-centered series for the performing arts in the United States. The series has four components: the Baxter Series presents major orchestras, operas, Broadway musicals, dance, and theater in a downtown facility; the Mount Series presents touring theater, musical, lecture, and dance programs on campus; the Forum Series offers a film lecture series emphasizing history, art, and

culture; and the Young Concert Artists Series builds new audiences for recital programs and supports the concert careers of promising young musicians. The influence of the Marshall Artists Series has been felt at many other institutions, largely because of Marshall's efforts and those of the University of Tennessee in the formation of the Association of College, University, and Community Arts Administrators in the 1940s. Another effort to enrich the campus and the community is exemplified by Influences, a unique design symposium sponsored by the art department and the institute for the arts. Influences attracts students, professionals, and others with an interest in design to the campus from a ever-widening geographic area encompassing nearly 20 states. Conceived as a look at design in the 1980s, the symposium investigates some of the influences, both shared and unique, experienced by leading designers representing many disciplines within the design profession, and does so in the light of a changing economy, new technology, and an educational system that is under close scrutiny. Among topics addressed have been design education, graphic design, design economics, the illustrator and social consciousness, working relationships between art directors and illustrators, and directions in typography. The most recent conference focused on "Sharpening the Creative Edge: Japan and the United States," at which eight prominent Japanese and American designers explored creativity and its manifestations in both countries.

Massachusetts College of Art

The Massachusetts College of Art is a public art college, with a full curriculum in visual arts and design. It is located in an urban neighborhood in Boston. In addition to offering its students excellent art programs, it seeks to be responsive to the multicultural environment of Boston and surrounding area. One such on-campus outreach program was the exhibition and symposium "Surviving Visions: the Art of Iri Maruki and Toshi Maruki." The project exemplified the college's commitment to

exploring the ways in which art functions as an active element in the society from which it derives. The murals painted during the last 40 years by the Marukis depict the tragedies of that period: Hiroshima, Auschwitz, Okinawa, Nanking, Minamata. Through their work, the Marukis bear witness to the horror of what has occurred and exhort their audience to work for peace and sanity in international and domestic affairs. For the "Surviving Visions" project, the college mounted an exhibition of six murals, the first major exhibition of the Marukis' work in the United States. The paintings were accompanied by didactic panels contexting the work, and by poetry written by the artists. To inaugurate the exhibition, the college held a symposium in which renowned artists and scholars discussed the role of the artist as commentator on, chronicler of, and participant in societal context. The project also included a major catalog, part of which was an expansion of the project's symposium. "Surviving Visions" attracted a large and diverse audience, ranging from college students, faculty, and staff to high school classes, doctors, artists, psychologists, teachers, and many members of the general public. A special series of school trips was arranged in which children discussed the exhibition with representatives of Educators for Social Responsibility. Many of the college's faculty held special classes in the gallery in order to initiate discussions of the themes and questions posed by the murals. With extensive local and national press, the exhibition drew a substantial number of visitors to the gallery. School study guides and the catalog continue to be distributed, further extending the reach of the program.

Memphis State University (TN)

Memphis State Univesity is centrally located in a residential area of eastern Memphis. Six colleges and three schools serve a student population of 21,000. The college of communication and fine arts is made up of four departments: art, music, journalism, and theater and communication arts, which includes the dance

program. The college recognizes its responsibility both to students seeking personal enrichment and those pursuing career goals. A unique feature of the college is the Institute of Egyptian Art and Archaeology (IEAA), a Tennessee Center of Excellence. Although the work of the institute is ongoing, a highlight was the Ramses the Great exhibition, the largest cultural event ever in the mid-South. The exhibition attracted 675,000 visitors from the greater mid-south, but also from as far away as Europe and Africa. In conjunction with the exhibition, IEAA trained over 1,000 speakers and docent volunteers in the largest Egyptological class in history; authored a 240-page exhibition catalog (which became the catalog for three other national exhibitions), and organized an international symposium on Ramses the Great, bringing together in Memphis the world's leading Egyptologists. Since that success, the institute exhibits the largest permanent college of Egyptian antiquities in the mid-South and houses the largest Egyptological library within a 500-mile radius. Educational packets created by the institute are available for use by all school systems in the area to teach the art and culture of ancient Egypt, a program to be enhanced by an educational curriculum being developed that focuses on the institute's own collection.

Metropolitan State College (CO)

Metropolitan State College is in a unique position in relation to public higher education institutions. As the largest of Colorado's four-year state colleges, it shares the Auraria Campus in downtown Denver with two other institutions: the University of Colorado at Denver and the Community College of Denver-Auraria. Metro State's students average 27 years of age; most are employed. It has one of the larger transfer programs in the region. The art department at Metro State offers majors in several areas and also serves the general student population. The department has a modern and contemporary art emphasis, with additional courses in these areas. The curricular offerings are enriched through two programs: the artist-in-residence program and

Local Talent, a program of visiting artists. The artists-in-residence program brings artists from across the United States to work with students, faculty, and community groups for a period of time, producing and discussing their art. The Local Talent program invites artists from the community and region to exhibit their work, do demonstrations, or hold critiques. This results in a greater variety of experiences for the campus and increased knowledge and respect between the campus and the community artists.

Midwestern State University (TX)

Midwestern State University (MSU), located in Wichita Falls, is a campus of over 5,300 students. The past few years have been characterized by growth and diversification. With considerable new construction on the campus, MSU has taken advantage of a Texas law permitting the use of 1 percent of building funds for the acquisition of art. In 1981, the administration and board of regents of MSU instituted the art acquisition program. The goal of the program is to select and acquire a collection of artworks for the benefit of the campus and the community at large. An art acquisition committee, chaired by a member of the board of regents and including faculty members, students, community representatives, and alumni, makes decisions about the purchases based on the use of the facility, the space available for art, available funds, and the general scope of the collection. Since the program began, over 200 artworks have been purchased with a budget of nearly $100,000. The collection includes historical photographs, works by MSU graduates, prints and posters of well-known artists, large commissioned sculptures, and other major works. Placing the arts in public environments has resulted in both a learning experience and a sense of pride for the campus and the community.

Moorhead State University (MN)

Located in the Red River Valley near Fargo, Moorhead State

serves some 8,000 students, mostly undergraduate. Established in 1885, Moorhead State was originally, and for many years, a teachers college. In recent years, it has broadened its curricula to include the arts, sciences, humanities, business, professions, and technologies. It now prepares students for a variety of careers. A successful program in the arts is the Bachelor of Fine Arts in graphic design. For over 20 years, the program has produced creative individuals who have almost universally attained successful employment in their profession. The curriculum includes design methodology, production techniques for print media, typography, symbols, diagrams, packaging, display, publication, graphic imaging, and historical perspective. The program operates with state-of-the-art computer graphic facilities. Each student has personal studio space with a drafting cabinet for the duration of his or her academic years. The program includes a three-month internship, with placements nationwide, and field trips each quarter to professional firms in cities. In their advanced years, all students have the opportunity to develop design solutions for campus and community activities, firms, and agencies.

Murray State University (KY)

 Murray State University (MSU) is located in far western Kentucky, more than 250 miles from the state's capital and the other urban centers of the Commonwealth of Kentucky. Within a 100-mile radius are the states of Tennessee, Illinois, Arkansas, and Missouri. MSU is the only university in a large four-state area that offers arts programs in dance, theater, music, radio-television, and visual arts. As such, it is the primary cultural provider within a wide geographic area. Its academic programs are complemented by a wide array of performances, exhibitions, and presentations. Central in the fine arts complex is the Clara M. Eagle Gallery, a striking exhibition space of more than 5,400 square feet. Operated under the auspices of the art department, Eagle Gallery has a full-time director responsible for a variety of

exhibitions and educational programs. A typical year includes six major exhibitions, exhibitions of the permanent collection, and student and faculty exhibitions, viewed by some 16,000 people each year. Two recent exhibitions demonstrate the wide range of art that is made available to the campus and region. A selection of art from the children of the Soviet Union, Czechoslovakia, and western Kentucky was displayed. Entitled "Children for Peace," the exhibition was accompanied by a seminar for area teachers conducted by noted Czech and American artists/educators. The program was filmed for subsequent broadcast throughout the Commonwealth by the Kentucky Television Authority. A traveling exhibition entitled "Nam and the Sixties," a photographic retrospective dealing with the Vietnam war, was presented in the gallery. An interdisciplinary campus committee, consisting of representatives from humanities, political science, and ROTC, planned a month-long series of programs on the significance of the war to American society. Attracting students and community people who are not regular visitors to the gallery, the exhibition did much to create vital dialogue and illuminate the many issues of the war. As a core component of the university's cultural outreach, the gallery reaches beyond the visual arts to include music and theater programs for the campus and community.

Norfolk State University (VA)

Norfolk State University is a comprehensive, senior, public institution located in downtown Norfolk. Its 7,700 students can pursue any of 71 academic programs. The school of arts and letters offers seven baccalaureate and four master's degrees in five departments, including fine arts and music. In the arts, students pursue curricula in literature, fine arts (general), graphic design, public school music, and music with an emphasis in media. Programs in the developmental stage include composition, performance, computer graphics, and American Studies. The curricular offerings are enriched by the university's location: reasonably close to Washington and New York, but also situated

in the Hampton Roads area, which is rich in arts resources. The university seeks not only to serve its campus constituents but also to assist with the growth of the arts in the region. Founded primarily by arts faculty, the Southeastern Virginia Arts Association presents festivals, forums, recitals, exhibits, summer youth theater, and other cultural programs in the community and at the university. The university promotes, houses, and facilitates many community projects. One example is Center Stage—a dance, music, and theater group of underprivileged community children who study on the campus on weekends. Another example is the month-long Festival of the Arts, which features some 20 events and many nationally recognized artists and performers.

North Carolina Agricultural and Technical State University
 North Carolina A&T is a land-grant, comprehensive, historically Black institution located in Greensboro in the Piedmont Triad. Founded in 1891, A&T has approximately 6,000 students from most of the 50 states and several foreign countries. The university has six schools and one college. The college of arts and sciences, the largest of the units, has 13 departments, including art, music, and theater division of speech communication. The university has two art galleries: the Taylor Art Gallery and The Mattye Reed Afro-American Museum. Both have extensive and valuable permanent art collections. Recently, the Taylor Art Gallery received several Calder Tapestries. But perhaps the most outstanding of the arts components at the university is the award-winning theater program. A&T's theater has won numerous local, state, and national awards over the years, including the North Carolina Theatre Association Excellence in Theatre Award, the Southeastern Regional Best Collegiate Production Award (for five years), and the American College Theatre Festival National Award at the Kennedy Center in Washington, D.C. Additionally, students and faculty have won many individual and group awards, such as several Irene Ryan Acting Scholarships, the

Lorraine Hansberry National Playwriting Award, and the David H. Library American Heritage Playwriting Award.

North Carolina School of the Arts

The most unique characteristic of the North Carolina School of the Arts (NCSA) is that it is the United States' first state-supported, freestanding, residential, professional training school in the arts for high school, college, and graduate students that is a part of a major university system. A constituent institution of the 16 campuses of the University of North Carolina, NCSA accepts students from within the state, the southeast, and other areas. The association of gifted students and artist-teachers creates a diverse and challenging environment for study and performance. In keeping with the intentions of its founders, the school is also dedicated to enhancing the cultural life of the the region and state through its performances and programs. Each of the professional schools (dance, music, drama, design, and production) has a core training program that has achieved distinction. NCSA graduates are found in major art entities and endeavors throughout the world. Special programs adding luster to the core experience include the International Music Program, which for more than 20 summers has sent a musical troupe from NCSA to Italy, Germany, and other European countries; the International Dance Program in London and Budapest; and performing groups that tour North Carolina and adjacent states each year. The school also extends opportunities to students of all ages through such extensive programs as Pre-Professional Dance, the Community Music School, and the Adult Center for Arts Enrichment. The school of music offers a career development seminar to familiarize students with the practical aspects of the professional arts world. More than 100 guest artists visit the campus each year for performances and master classes, complementing the daily work of the faculty professional artists, who continue active professional lives. The NCSA is a model for

professional arts training that is currently being emulated by schools across the nation.

Northeast Louisiana University

Northeast Louisiana University (NLU), begun as a junior college in 1931, and was granted senior status in 1950. Today, the university serves over 10,000 students and offers both undergraduate and graduate degrees. The campus is located in Monroe, a city whose metropolitan area population exceeds 100,000. Monroe, with its Civic Center, Strauss Playhouse, Masur Museum, West Monroe Convention Center, and park system, offers a wide variety of cultural and popular programming for the entire region. Performances, concerts, and other artistic events are presented by the Twin-City Ballet, Monroe Symphony, Northeast Concerts Association, Strauss Theatre, and Masur Museum. NLU's division of the arts gives full support to all areas of the arts, particularly dance, music, theater, and the visual arts. In addition to its curricular offerings, the division capitalizes on the cultural opportunities of the city. One such example of cooperation is a two-week dance workshop held on campus each summer. Cohosted by the department of health and physical education and the Twin-City Ballet Company, this workshop offers a varied and intensive program in classical ballet, pointe, character dance, modern dance, jazz, tap, choreography, and technical ballet. The purpose of the workshop is to give additional learning opportunities to young and talented dancers. Admitting students 10 years of age and older, it serves over 100 students each summer. Guest faculty from the United States and Europe enrich the artistic education of participants.

Northeast Missouri State University

A public liberal arts and sciences university, Northeast Missouri enrolls approximately 6,000 students in 56 undergraduate programs and nine graduate programs. The advantages of a small university are present in the closeness of academic

resources, the automated library with on-line access throughout the campus, the informal interchange between students and faculty, and the easy accessibility and increasing integration of the arts into the lives of the students. However, the fine arts—music, art, drama, and dance—are not only important for students; the university commitment to the arts extends beyond the confines of the campus. The university recognizes the place of the arts in uplifting the spirit of the widest possible campus and regional audience. Toward this end, the university, in 1899, inaugurated the enduring and influential Lyceum Series. Over the 90 years of its existence, the Lyceum Series has provided students and the general pubic with cultural, intellectual, and entertaining performances and presentations by such notables as James Dickey, Eleanor Roosevelt, Rise Stevens, Alexander Haig, Jeanne J. Kirkpatrick, and such groups as the Vienna Boys Choir, Chicago Opera Ballet, New York Pro Musica, Roger Wagner Chorale, Dave Brubeck Quartet, the St. Louis Symphony, the Guthrie Theatre, and the Preservation Hall Jazz Band. All performances are free to students and faculty, with a nominal fee charged to the general public.

Northern Illinois University

Northern Illinois University (NIU), located in DeKalb, just outside Chicago, is a multipurpose educational institution serving nearly 26,000 students. NIU is one of three Illinois institutions ranked as schools of choice for Illinois students with the highest ACT scores. It is also the first choice among transfer students from community colleges, as more of them complete their education at NIU than at any other college or university in the state. The college of visual and performing arts comprises the schools of art and music and the theater department. The major arts areas are linked together philosophically and logistically. They share resources, interact in terms of their curricla, and are jointly charged with the mission of providing a "center for the arts" within the university and its service region. Their success in

doing so is readily acknowledged within the region and frequently affirmed in national and even international settings. For example, the NIU Philharmonic has received First Place as the best student symphony orchestra in the nation every year since *down beat* magazine established the "deebee" award competition—a total of 11 consecutive years. The NIU Jazz Ensemble, also a "deebee" award winner, has toured Europe and played in major festivals. The NIU Wind Ensemble has taken a First Place "deebee" award in seven of the last eight years. NIU's school of art, one of the two or three largest in the nation, operates galleries both on campus and in downtown Chicago that attract some 20,000 visitors annually. The theater department oversees a remarkable collection of historic opera stage sets of the Lyric Opera Company of Chicago. An example of the quality of curricular offerings is the Design Emphasis within the B.F.A. degree in art. This emphasis affords rigorous preparation for careers in interior architecture, electronic imaging, photography, and visual communication. More than half of the undergraduate art students major in design; one of every 34 students at NIU majors in design. The college has taken steps to ensure the quality of its graduates, with rigorous portfolio and course requirements. One important aspect of the design programs is a course called "Design Field Experiences," which permits students to have semester or summer paid cooperative education experiences. Students who fail to complete the first portfolio review are converted to the B.A. degree program, which is also respected by employers. The lasting, significant results of the design program are that NIU is increasingly identified in the Midwest and on both coasts as an institution that prepares designers for immediate usefulness in their fields and does so while supplying a 41-semester-hour program of general education.

Northern Kentucky University

Northern Kentucky University, founded in 1968, is the youngest of the the Commonwealth's eight universities. Located

in the rolling countryside seven miles southeast of Cincinnati, the campus serves some 8,000 students from throughout the Greater Cincinnati area. Programs are offered in the colleges of arts and sciences, business, professional studies, and law, and University College. As a part of its numerous arts offerings, Northern Kentucky sponsors a biennial Year End Series of New Plays, the Y.E.S. Festival. The festival presents three world-premiere productions in rotating repertory. The most recent festival finalists were selected from over 225 entries representing virtually every state. The three plays produced by the Theater Department were *Seed of Darkness* by Larry Riggins (Long Beach, CA), *Boardinghouse Stew* by E. E. Smith (Seattle, WA), and *The Beast* by Joseph M. Corral (New York, NY). Two productions received six performances each on the Fine Arts Center Main Stage, and the one production for the Black Box Theatre received seven performances. The plays each had two critique sessions, attended by the playwrights and conducted by guests from the professional and educational theater worlds; the critiques were open to the public. The festival is an important element in furthering new plays and in enriching the cultural climate of the campus and the region. In recognition of this, the 1987 Y.E.S. Festival won the Post-Corbett Award, a prestigious award in the arts for Greater Cincinnati.

Northern Montana College

Northern Montana College enrolls approximately 1,700 students. Located in North Central Montana, far removed from the other six institutions of the Montana University System, the college serves a large segment of the state from North Dakota to Idaho as well as three Canadian provinces, a service area of approximately 35,000 miles. The nearest metropolitan area, the city of Great Falls, is over 100 miles to the south. Within this setting, the college sponsors the Northern Showcase as a means of bringing professional artists to the campus and spotlighting local and campus arts programs and artists for the campus and community residents. The showcase offers a blend of amateur

and professional talent, including three college/community plays, three concerts, and three professional events. These events occur on campus and in the community. In addition to these primary events, the showcase cosponsors events with other campus and community organizations.

Portland State University (OR)

Portland State University (PSU) is located in Portland, the largest city in Oregon. Founded as an extension center, it grew into a college, and then a university. It draws students from throughout Oregon and southwest Washington. With its inner-city location, it can easily interface with elements and institutions of the city. This is certainly true with the arts. The university is two blocks from the Art Museum and the Oregon Historical Society, and four blocks from the Performing Arts Complex, consisting of a concert hall, intermediate theater, and variable seating showcase theater. The Civic Auditorium is just four blocks away. The Oregon Symphony Orchestra, Portland Opera Association, Shakespeare Theatre, and numerous other performing groups have homes in Portland. Portland is also the home of the Pacific Ballet Theater and Ballet Oregon, as well as several modern dance companies. An example of how the university interacts with community groups is the Contemporary Dance Season. The PSU Department of Dance, which offers novice and advanced traditional ballet classes, as well as jazz dance, has become most well-known for its contemporary dance offerings. Students who have completed the certificate studies have worked with David Parsons and Stephen Petronio. A resident company, Judy Patton and Company We Keep, performs in the western states. In order to provide additional role models for students, to open the community to contemporary dance, and to bring excellent contemporary dance to the city, the university sponsors the Contemporary Dance Season. The university provides excellent facilities for the performances; the professional visiting companies have been generous in sharing their time with students

through workshops, master classes, and residencies. The efforts are supported in part by ticket sales, state and local arts councils, and the National Endowment for the Arts. In addition to the enrichment of university students, Portland's magnet arts high school's dancers benefit. Finally, the community has developed a growing and sophisticated audience for the performances of Merce Cunningham, Sankai Juku, Momix, and others. In its role as the only regular contemporary dance series, the Contemporary Dance Season fulfills a need for another dimension of dance in the community in addition to ballet.

Radford University (VA)

Radford University is a comprehensive university with undergraduate and graduate programs. Since 1972, the enrollment has increased dramatically by more than 90 percent, to 7,854 students in 1987. Most of its students are from Virginia schools. Because of this fact and the rural setting of the university, it seeks to broaden educational opportunities. Radford offers arts students an opportunity to study at Middlesex Polytechnic in London, England. Through a student exchange program, students from this rural setting are able to spend one semester studying their art discipline in a major metropolitan arts center. The participating students benefit from experiencing the arts in one of the world's great arts centers, they experience a different educational approach, their values are challenged by the process of living abroad, and their perspectives about their art are influenced. Radford students who do not participate benefit from attending classes with exchange students from England.

Ramapo College of New Jersey

Ramapo College of New Jersey is located in the community of Mahwah near the New York state line west of the Garden State Parkway. Established in 1969, Ramapo is a college serving nearly 4,000 students, equally divided between undergraduate and graduate levels, through programs in liberal arts, sciences, and

professional studies. The school of contemporary arts is one of seven academic units. The programmatic thrust of the school is to offer academic programs in the arts and communications within the context of an interdisciplinary liberal arts college. Central to all contemporary arts programs and courses is the belief that the arts are an essential part of contemporary experience and that they should occupy an important position in the liberal arts curriculum. Central also is the belief that the various areas are all closely related and involved with the same issues and problems; they affect almost all other fields of study as well. Studio and performing courses must contain broad intellectual and analytic elements; history and theory courses should serve to address real social issues and creative ends. Arts programs must also provide students with international and multicultural perspectives. Toward these ends, the school of contemporary arts has a mandatory series of introductory interdisciplinary core courses in communication, visual, and performing arts that offer a broad scope of history and practice desirable for a liberally educated peson. The upper-level core is planned to provide a varied and changing emphasis on different aspects of larger interdisciplinary issues in the contemporary arts, including such topics as contemporary arts criticism, impressionism and symbolism, and the dramatic element. The programs serve a wide range of students, from those who are interested in enriching their liberal arts education to students planning a profession in the arts.

Rhode Island College

Rhode Island College (RIC), founded in 1854, is a public, liberal arts-oriented institution serving over 7,000 students. Located in Providence, the college has traditionally emphasized teacher education and allied health programs. Among the disciplines with the highest number of majors is liberal arts. The college seeks to provide professional education in the arts as well as to serve as a cultural resource to the students and the local

citizens. A unique feature of the art programs at RIC is the Fine and Performing Arts Commission, headed by the fine arts director. The funds for the commission come from a student fine arts fee of $25 per student for the academic year. This fee provides funds for 14 recognized student organizations that make proposals for their activities for the entire student body. The art department's organization sponsors guest artists who give slide lectures, demonstrations and/or workshops, trips to museums and galleries in major cities, and student exhibitions. The dance company is the core of the dance program and supports residencies by well-known dancers and choreographers, dance performances, and regional festivals. The film society schedules weekly showings of classic and avant garde films, student film competitions, and lecture-workshops by filmmakers. The theater organization produces four to five outstanding plays and musicals each year. The music department has several student organizations that present concerts by instrumental and choral groups. The performing arts series brings outstanding theater, music, and dance performers to RIC. All of these offerings are in addition to those regularly expected in the various arts curricula and programs.

San Francisco State University (CA)

San Francisco State University (SFSU) is one of the 19 campuses of the California State University. Located in a large and diverse urban setting and with a student population approaching 28,000, SFSU recognizes its special urban character and encourages a close relationship with the San Francisco Bay Area community. The school of creative arts, one of eight schools composing the university, consists of the departments of art, broadcast communication arts, cinema, dance, design and industry, music, theater, and the interdisciplinary inter-arts center. The school offers undergraduate and graduate programs in performing arts, visual arts, and media arts. In addition to its commitment to young artists, it conducts major arts "outreach"

programs. Examples of the catalytic programming for arts on the campus and in the larger community are the Arts-Bridge to College, a program offering special admission and access to selected courses to SFSU for gifted high school students in the arts; the AudioVision Institute, a description technique developed at SFSU allowing the visually impaired to "see" film, televison, and theater by means of audio information provided by trained describers; and the Creative Arts Forum, an annual event stressing multicultural perspectives and attitudes in the arts. Other efforts of the school include the Advanced Computer Imaging Center, which utilizes cutting-edge technology in artistic utilization of computer potentials; the Design and Industry Exposition, a biannual showcase for innovative and creative solutions SFSU students have found to a wide variety of commercial and design problems; the Institute of International Media Communications, a series of workshops for media professionals from developed and developing nations; the Broadcast Industry Conference, which brings professionals at the local, national, and international levels into contact with SFSU students for the purpose of sharing information and ideas; and the Music Recording Industry Certificate Program, intended to align education goals with the needs and expectations of the music and recording industry. The school's departments offer a wide array of exhibitions, music performances, dance presentations, and theater performances for campus and community audiences.

Shippensburg University of Pennsylvania
Shippensburg University is in a rural area 40 miles from Harrisburg and 90 miles from Washington, D.C. It offers programs in the arts and sciences, business, and teacher education to some 6,000 undergraduate and graduate students. Among its arts offerings are visual arts, music, theater, literature, and radio-television. An undergraduate disciplinary arts major has recently been established. This program is flexible and allows

arts students to develop a program of study that meets their personal needs in art, music, theater, and literature. Each student has a senior project, to be accomplished over two semesters. The first semester is devoted to research and consultation with an assigned adviser and will include a biweekly seminar. This seminar includes progress reports from students, discussion of research procedures, and presentations from faculty and guests. The culminating project of the second semester takes the form of presentations such as art exhibitions, recitals, or theater presentations, accompanied by slides and videotapes. The activities must also be accompanied by an essay that comments in detail on the project, demonstrating an awareness of relevant aesthetic theory and vocabulary. Students who pursue this course of study have unique opportunities to develop their art form, their research skills, and their writing/presentation skills.

Slippery Rock University of Pennsylvania

An hour's drive north of Pittsburgh, Slippery Rock University is a multipurpose institution offering programs to some 6,000 students in education; health, physical education and recreation; humanities and fine arts; natural sciences and mathematics; social and behavorial sciences; and graduate studies. The university seeks to provide excellent education for its students and extensive service to its region. A distinctive outreach program in the arts is the Summer Academy for the Performing Arts. With the cooperation of Midwestern Intermediate Unit IV—a coordinating agency for public schools in the surrounding three counties—the university hosts 30-35 talented high school students each summer. These students, freshmen through juniors, are selected by audition to participate in an intensive period of training in vocal music, dance, and acting. University faculty teach daily classes and assist the students in presenting a culminating showcase presentation. All costs of the academy are borne by the university and the Intermediate Unit.

Southeast Missouri State University

Southeast Missouri State University, located in Cape Girardeau on the Mississippi River, serves some 8,800 students in five colleges and 36 departments. The university, as the primary public center for the arts in the southeastern region of Missouri, attempts to undertake public programs in the arts and humanities that reflect faculty research and can generate high levels of interest in the general population. These activities usually take the form of lectures, exhibits, or performances. Examples are the sponsorship of a lecture and exhibit of the James T. Dennis Collection of Egyptian Antiquities. Over 900 area residents attended the introductory lecture. Another public program resulted in the performance of musical manuscripts from a group of German immigrants into southeastern Missouri who, in 1838, established the Missouri Synod Lutheran Church (for many years the largest segment of Lutherans in the United States.) These musical manuscripts were edited for male choir by a professor of music and were performed in Cape Girardeau and St. Louis by the university choir and the brass ensemble players from the St. Louis Symphony. These presentations were heard by audiences totaling over 2,000 people. An example of the type of public programming in the humanities was the lecture and exhibition of the L. D. Brodsky Collection of William Faulkner materials. These materials, for many years in the private collection of a Missouri collector, have now been catalogued and made available to scholars and interested public. The largest private collection of Faulkner manuscripts and papers known, they have altered the direction of Faulkner scholarship. The collection was exhibited at the university museum and viewed by some 1,500 people. These and other endeavors help the university heighten the visibility of the arts and humanities; make their benefits available to the people of the Southeast; and attract national attention and advanced scholarship in those disciplines.

Southeastern Louisiana University

Southeastern Louisiana University (SLU) is in Hammond, the crossroads of the South and less than an hour from Baton Rouge and New Orleans. SLU has about 9,000 students, 350 faculty, and offers 73 baccalaureate, 18 master's, and seven associate degree programs. In 1986, in the face of a defunct football program, the university sought a special endeavor for its annual Homecoming. It was determined that Homecoming activities should focus on a celebration of culture and scholarship, and thus was created Fanfare. The result was a celebration of over 30 performances, exhibitions, and scholarly presentations during October 1986. With events ranging from Black Gospel to ballet, from lectures on regionally significant topics to James Watt, and from art exhibitions to Edward Albee, Fanfare has provided the people of the Florida Parishes broad-ranging and significant programming that otherwise would not be locally available. Proving such an event can be a viable alternative to sports in attracting alumni to the campus, over 9,000 people attended the events of that first Fanfare. While the return of football is imminent, Fanfare will continue to be an essential component of the university.

Southeastern Oklahoma State University

Southeastern Oklahoma State University (SOSU) is located in Durant, a small town of some 13,000 residents. The region's economy is driven primarily by manufacturing, processing, and agriculture. The university is 13 miles from Lake Texoma, which draws over 11 million tourists each year. Among the campus and outreach efforts of the university are the Oklahoma Shakespearean Theatre and the Children's Theatre. These programs provide students an opportunity to gain experience in acting, managing, designing, costuming, and directing. Drama students perform in one children's theater production, four adult productions, and a senior recital production during one school term. They also have opportunities to perform in the Shakespearean Festival. Over the

years SOSU students have won Irene Ryan awards from the American Theatre Festival of the Kennedy Center. In addition to serving students, the productions reach into the community and region. They provide adults, students, and children with an opportunity to experience live theater, many for the first time in their lives.

Southern Arkansas University

Southern Arkansas University (SAU) is located in Magnolia, a growing, progressive town in the heart of a farming, timber, and oil-producing area in southwestern Arkansas. SAU is a three-campus system composed of a technical college, a community college, and a regional state university. One of the institution's major, systemwide goals is to provide students with the opportunity to explore—both in theory and in practice—aesthetic concerns. Toward that end, the university sponsors three artists in residence to work on campus and in the communities. In the fall of 1987, a musician, a visual artist, and an actor were in residence on campus and worked in local elementary and secondary schools. In the course of the residencies, a class entitled "Fine Arts Survey" was developed in the Magnolia High School. Encompassing art, music, and drama, the course provided students with an overview of the arts. Resident artists not only enriched the classes but also assisted the teachers in planning and implementing the course. This has led to further development of existing programs in art, music, and drama on the university campus and in the public schools of the region.

Southern Illinois University at Edwardsville

SIU at Edwardsville was founded in 1957. Today, it serves nearly 10,000 students through seven undergraduate schools and a graduate school which constitutes some 20 percent of campus enrollment. Located 15 miles from St. Louis, Missouri, the campus consists of contemporary architecture on 2,600 acres along the Mississippi River. When the campus was being planned

in 1961, a symposium of renowned planners and civic leaders was convened to examine and explore the question of what the nature of a modern university should be. Included in this group were R. Buckminster Fuller, Sybil Maholy-Nagy, landscape architect Hideo Sasaki, architect Paolo Soleri, city planner Edmund Bacon, sociologist Howard Becker, and industrialist Arnold Maremont. The decision was made to create an educational environment conducive to learning at many different levels. One of the practical results of this concept was a campus where virtually every corridor, conference room, and hall is graced with works of art. In its early days, the university hired art critic Katherine Kuh to acquire works for the new campus. Among her acquisitions were works by Rodin, Noguchi, Max Ernst, Yasuhide Kobashi, and the Louis H. Sullivan Architectural Ornament Collection. Over the years, the acquisitions have grown to over 4,000 works. As the collection has grown, the university museum, which has stewardship of the collections and administers the exhibition programs, has designed a project entitled "ART*I*FACTS," which employs visual communication in the everyday environment to augment informally that which is taking place formally in the classroom. The program was designed to help increase visual and cultural literacy and to place students in close and constant contact with art and other objects from native and foreign, contemporary and historic cultures. Originally displayed in random fashion to complement the ambiance of architect Gyo Obata's buildings, the art is now presented in a more didactic manner that includes written information on the surrounding art; these brochures are available at 26 "Art Stops" throughout the campus. A source of enlightenment and pride, the collections help students and guests re-create themselves through the contemplation of the objects they encounter throughout the campus.

Southwest Texas State University

Southwest Texas State University, a 20,000-enrollment

university located in San Marcos, is just 26 miles from Austin and 50 miles from San Antonio, one of the fastest-growing regions of the nation. Austin is known for its arts diversity, while San Antonio is a center of cultural diversity, especially Hispanic culture. In this culturally rich area, Southwest's department of speech communication and theater arts has a faculty of 11 who serve 150 majors and 100 minors. Within that department is the Children's Theatre Program. University students audition for roles for the touring production. If selected, they must arrange to be free on Tuesdays and Thursdays during each spring semester. After an on-campus run, the children's show tours to public schools within a hundred miles of the campus. Each year approximately 12,000 school children view the production. Original shows that have been produced by Southwest have been featured at the International Children's Theatre Festival near Washington, D.C. Plans are underway to develop a videotape of productions with teachers' guides. In the summer of 1988, the college and community sponsored a summer children's art emphasis featuring two children's shows.

State University of New York at Purchase

SUNY Purchase is one of America's first institutions of higher learning—public or private—to combine the educational goals and traditions of the university and the conservatory. The university was founded in 1967 to provide a unique teaching community. It combines within one campus a concentration of both liberal arts and fine arts students and faculty, enabling them to share in each other's growth in ways that are rare in college communities. SUNY Purchase is located in Westchester County, 45 minutes from midtown Manhattan. This location combines the advantages of a rural setting with proximity to a major metropolitan area. The architecture of campus buildings has been internationally recognized as an extraordinary achievement. Following a master plan designed by Edward Larrabee Barnes, the campus represents the contributions of many distin-

guished contemporary architects, including Venturi, Gwathmey and Siegel, Johnson, and Rudolph. The full-time student body of some 2,800 is almost equally divided between the liberal arts and the fine and performing arts. The 160 faculty members are recognized by their peers in their fields, receiving fellowships from the Guggenheim Foundation, the National Endowments for the Arts and Humanities, Fulbright, and others. Students in the fine and performing arts receive all the advantages of conservatory and professional training, plus liberal arts experiences that are based in the breadth and depth of a college setting. SUNY Purchase believes that the artist not only is influenced by a broader community of people and ideas but should also participate in that community. Students enrolled in the school of the arts receive intensive professional training beginning their first semester. Three-fourths of their education is in the arts, the balance in liberal arts. Frequent performance or exhibition is a requirement, allowing significant interaction between faculty and students. To enrich the cultural environment, the Neuberger Museum mounts 3-6 major exhibits each year and arranges for student shows. The Performing Arts Center not only hosts student productions, but presents a professional series with approximatly 30 events annually. Each summer since 1980, the campus has produced PepsiCo Summerfare, a major international arts festival. All this effort enhances the lives of tens of thousands of people annually—students, faculty, school children, artists, and the community.

State University of New York College at Buffalo

SUNY Buffalo, serving some 23,000 graduate and undergraduate students, offers programs in the arts and sciences and in a wide range of preprofessional fields. The arts are an important curricular and outreach feature of the university. In the fall of 1987, SUNY Buffalo presented an opening arts festival as part of a year-long celebration of the arts to commemorate the reopening of Rockwell Hall, following a $12-million renovation.

Rockwell Hall provides the college and city of Buffalo with a new, sophisticated auditorium with the capacity and capability to present major arts events in the only fully equipped mid-sized theater in the area. The festival featured premieres of works by living American artists with a national reputation and a Buffalo connection. It featured an array of musical, theatrical, and dance presentations, together with installations, exhibitions, and residencies in the visual arts. The celebration introduced the community to the new facility in a special way by highlighting the college's role in Buffalo as a leading presenter of creative work and as an enhancer of the national cultural scene through the creation of new works. The festival served a diverse audience with a variety of classic, contemporary, new wave, and traditional performances in art, music, theater, and dance. The positive reactions of 53,200 people at 140 events positioned the campus as a leading cultural center in an urban area of a million people.

State University of New York College at Fredonia

On a campus designed by architect I. M. Pei, SUNY Fredonia is southwest of Buffalo. It serves some 4,500 students in undergraduate and graduate programs in the arts and sciences, in preprofessional programs, and in specialized programs in health, labor relations, urban studies, and the like. Through quality programs in art, music, theater, and communications media, the university serves its major students. But it also seeks to enrich the cultural climate of the region. One of the vehicles for achieving this dual role is the Mainstage Theatre Series, produced annually by the drama department in cooperation with the school of music and the Rockefeller Arts Center. The series offers four plays—three presented in the 400-seat Marvel Theatre and one in the 200-seat experimental Bartlett Theatre—by university students under the direction of university faculty. The shows are designed by faculty and advanced technical students; technical crews of students execute the designs, costumes, and

lighting. The plays are chosen to give student actors and audience members exposure to dramatic literature of all periods and styles. The series draws to its audience the general public from the immediate area and from throughout the region. About one-third of the typical audience is composed of students and faculty, so the series is a major link between campus and community life.

State University of New York College at New Paltz

The State University College at New Paltz is a comprehensive campus with an enrollment of 8,100 students. Located in the Mid-Hudson region, 1-1/2 hours north of New York City, New Paltz is in one of the richest cultural areas of the country. The school of fine and performing arts consists of five departments (art education, art history, art studio, music, and theater) and a fully staffed art gallery. The campus is enriched by a faculty recognized nationally and internationally. Art studio faculty have exhibited throughout the world, have won numerous international awards and grants, and are represented in the collections of major museums such as the Metropolitan Museum and the Brooklyn Museum. Of special note in music is the presence of University Professor Vladimir Feltsman, the internationally known pianist and recording artist. In addition to teaching, Professor Feltsman offers the week-long Feltsman Piano Institute each summer and master class weekends throughout the year. Professor Felstman and other members of the music department appear each summer in the Music in the Mountains Festival which, since 1982, has been devoted to the performance of twentieth century music, particularly American music. In addition to a wide range of arts degree programs, including music therapy, studio art, art history, art education, and several aspects of theater (including musical theater), SUNY New Paltz provides students with numerous special opportunities for enrichment. Easy access to New York City enables students to experience many forms of superb

art. Art history students can participate in the On-Site Arts History Studies Abroad program and visiting lecturer series. The college has a student exchange program with Middlesex School of Art and Design in England and a year-round program in Urbino, Italy, for art studio and art history students. Each January, the London Theater Seminar, a two-week "winterim," is especially attractive to theater students. In conjunction with New York's renowned Circle Repertory Theater, SUNY New Paltz's Play Company is devoted to the writing and production of new plays. Thus, the curricula and special opportunities complement each other and create a rich arts environment for students.

State University of New York College at Potsdam

SUNY at Potsdam is located in upstate New York in the area known as the North Country. Situated in a rural community of about 5,000 residents, its two closest metropolitan neighbors are Ottawa and Montreal. The college has an enrollment of 4,300 students drawn from throughout the state. It consists of three schools, one of which is the nationally known Crane School of Music, which in 1986 celebrated its centennial. Approximately one-sixth of the college students major in the arts, with about one-half pursuing a degree in music education. The college also offers majors in art, dance, and theater, all located in the school of liberal studies. The most obvious feature of the arts at Potsdam College is their pervasiveness. In addition to numerous productions featuring faculty and students, there is a constant stream of guest artists, artists-in-residence, and major professional concerts. A large number of sculptures dot the campus, and paintings are displayed in all campus buildings as well as the gallery. Thus, all students have easy access to the arts. This pervasiveness became all the more prominent in the fall of 1988, when a new general education curriculum required every student in the college to take two courses in the arts, one involving participation and the other criticism and analysis.

Tennessee Technological University

Tennessee Technological University, located in Cookeville, was established in 1915; its growth as an institution has been closely interwoven with the development of the Upper Cumberland region of Tennessee. After several metamorphoses, the university now focuses on its academic program, with instruction as its major component, and as the central and fundamental purpose of the institution. While the university serves regional and national needs and must attempt to meet numerous responsibilities, all of the programs and responsibilities derive from its academic mission. The academic programs include general education courses and provide all students with the fundamental knowledge and skills necessary for advanced work. A unique feature of the university's arts offerings is the Joe L. Evans Appalachian Center for Crafts, an educational facility providing opportunity for students to explore contemporary art as well as traditional crafts in five basic media: clay, fibers, glass, metals, and wood. Located on 600 acres overlooking Center Hill Lake in middle Tennessee, the craft center's facilities are among the finest and best equipped in the nation. Total space exceeds 87,000 square feet, including over 50,000 square feet of studio space, exhibition and sales gallery space, a library, and housing designed to accommodate up to 128 students. A B.F.A. degree is available, a B.S. degree in crafts marketing has been established, and postgraduate credit is available. Alternative nondegree education programs are available through apprenticeships and internships. A concentration of 1-3 week workshops is offered during the summer months by visiting artists from around the country. Weekend workshops and evening classes are taught throughout the year. This facility and its programs will help to train artists and preserve the craft/art traditions and disciplines in wood, glass, metal, fiber, and clay for years to come on a regional, national, and perhaps international level.

Texas Woman's University

Texas Woman's University (TWU) is a comprehensive public university, primarily for women, offering both undergraduate and graduate degees programs to some 8,300 students at three locations in Denton, Dallas, and Houston. The university is organized into three academic units: the undergraduate general division, in which enrollment is limited to women, and the institute of health sciences and the graduate school, both of which are open to men and women. Among the nation's leading providers of health care professionals, TWU is also noted for its library and information studies, performing and visual arts, fashion and textiles, nutrition and food sciences, family and consumer studies, teacher education, adapted physical education, and counseling psychology. In the arts, TWU has a department of music and drama, which maintains close relationships with the department of dance. This arrangement permits and encourages many collaborative efforts such as musical theater, opera, and other performances. Students and faculty gain valuable experience in these cooperative efforts. Open auditions are held for male roles throughout the region. It should be noted that in a single-sex institution such as TWU, students learn to perform all tasks associated with mounting a production. There is no question of reserving certain tasks for male students and others for female students. This wide familiarity with all aspects of production benefit the students in their careers.

Towson State University (MD)

Towson State is located a mile and a half north of Baltimore. Established in 1866 as a teachers college, it now offers graduate and undergraduate programs in the arts and sciences and in certain professional fields to over 11,000 students. The arts have long been a strong component of the university. A recent development in the college of fine arts and communication was the initiation of an international Dance Exchange Program be-

tween Towson State and the renowned Leningrad Conservatory in the Soviet Union. To inaugurate the exchange program, the Towson State dance faculty and Dance Company visited the Leningrad Conservatory for one week. Members of the Towson faculty conducted workshops in jazz, modern, and tap dance, and the company gave several performances for students and faculty of the conservatory. The exchange program brought Nikita Dolgushin, Dean of Ballet at the Leningrad Conservatory and Soviet Ballet star, to serve as guest artist at the Towson State International Ballet Symposium. The exchange then enabled 27 students and teachers from the Leningrad Conservatory to visit Towson State to offer workshops in traditional ballet and to perform for the university and larger communities. Future plans call for Towson faculty and/or students to spend a semester or year at Leningrad and for their Soviet counterparts to spend an equal amount of time at Towson.

University of Arkansas at Monticello

The University of Arkansas at Monticello (UAM) is located some 90 miles southeast of Little Rock. It serves nearly 2,000 in the arts, sciences, and professions. The department of fine arts encompasses two academic programs—music and art—which offer the Bachelor of Arts degree. Both highly visible programs are committed to strong programs for their students and outreach into the region. A primary hallmark of the arts at UAM is the performing groups. As an expression of appreciation for their efforts, an "Adopt a Band Member" project was undertaken in which a campus/community sponsor purchased a band uniform for a specific student. A television station in the state provided extensive coverage of the campus/community event, including the half-time performance of the band at a football game in which patrons stood with their "adopted" students. The story aired on a segment of weekly feature entitled "Spirit of Arkansas." In this small, but important, way, the campus and the community were drawn closer together.

University of Central Florida

Located in Orlando, the University of Central Florida (UCF) is a university which, in addition to traditional academic offerings, devotes attention to programs relating to the economy of central Florida—tourism, banking, aerospace technology, electronics, and health. UCF offers curricula in music, art, and theater and uses its arts resources to culturally enrich the region. One program is specifically designed to reach beyond the campus. The art department is currently developing undergraduate and graduate programs in community arts. These programs will be interdisciplinary, community oriented, and will emphasize the traditional disciplines of the visual arts, psychology, anthropology, music, and theater to prepare students for careers in administration, art education, and therapeutic expression. Students will learn to facilitate arts programming and encourage artistic activities to stimulate, challenge, and educate community members, including those who are often overlooked or neglected. Special emphasis will be placed on the development of successful programs sensitive to the needs and aesthetic preferences of varying cultural groups, older adults, and people experiencing mental and physical disabilities. The purpose of the program is not only to encourage a greater awareness and involvement in the visual arts, music, and theater, but also to help facilitate the use of artistic participation as a means of communication, as a way to establish a sense of identity, and as a way of promoting good health. Students will study culture-based aesthetics and what that means in terms of multicultural education and will examine art and politics, economics, and mental health. Issues of ethnicity, gender, class, age, and occupation will be studied. The functions and purposes of art in society will be examined. Program development skills will be developed and then translated into community arts.

University of Colorado at Colorado Springs

Founded in 1965, the University of Colorado at Colorado

Springs now serves nearly 4,000 students. Among its 11 academic divisions is the college of letters, arts, and sciences. In addition to offering academic programs in the fine arts, the university has sought to become an arts resource for the region. The Gallery of Contemporary Art was created in 1981 to serve the university and the Pikes Peak region. The major goal of the gallery is to organize and host exhibitions of contemporary artists of national and international significance that would otherwise be unavailable to the university community and region. The gallery's exhibition schedule, representing a diverse range of subject matter, media, cultures, and regions, is designed to attract a new and growing audience as well as to sustain the interest of its continuing supporters. Gallery exhibitions and programs are offered both as community services and as adjuncts to the instructional function of the university. The gallery consists of more than 6,400 square feet of exhibition, storage, workshop, and classroom space. More than 15,000 people visit the Gallery of Contemporary Art each year to view the exhibitions and participate in its programs. A nonprofit organization, the gallery receives its funding from the university, corporate and private donations, and state and federal grants.

University of the District of Columbia

The University of the District of Columbia is a public, urban, land-grant, open-admissions institution offering offering undergraduate and graduate degrees to some 10,000 students. The university has the resources of a major international city; the university's population is broad, international, multicultural, and multiethnic. This benefits the total campus and is a particular strengh for the arts. Access to major and neighborhood galleries and performance halls enriches the campus offerings. Given the university's clientele, the arts have attempted to develop programs of a somewhat nontraditional nature, focusing on a global perspective. For example, Afro-American art history is required of all art graduates. Many cultures are incorporated

into art history and art appreciation, courses that traditionally have presented only the art of Western Europe. Another example of the university's reflecting the interests of its students and constituents is the curriculum for classical and gospel church music. The students are encouraged to become directly involved in the music of the community, to enrich it, and to learn from it. UDC will continue to offer some unique programs and emphases that are responsive to its multicultural population and its place in an international city.

University of Hawaii at Hilo

The University of Hawaii at Hilo is located on the largest island in the Hawaiian archipelago. The 3,500 students enrolled in the university's three colleges are as culturally diverse as the state itself. Pacific Islander, Eskimo, Indian, Asian, Hawaiian, Filipino, Japanese, Chinese, Korean and Caucasian students make up the cultural mosaic so unique to Hawaii. Hawaii's location, a crossroad for trans-Pacific travelers, has engendered an active interest in cultural studies. This interest extends to the arts, where course offerings and associated activities reflect a continuing interest in cultures that fall outside the mainstream of daily American life. The Performing Arts Department, comprising music, drama, and dance, actively participates in multicultural activities through regular course offerings, faculty development activities, and performances. Courses attract a wide range of on-campus students, but also enroll a number of community residents, often elderly. Music courses include "Music in World Culture," "Introduction to the Music of Polynesia," "The History and Development of Hawaiian Music," "Japanese Music," and "Art and Music of Asia." These classes often use community resource persons who are considered "treasures" for their contributions to the perpetuation of their cultures. As enhancements to the academic programs, concerts are presented throughout the year that feature ethnic music. Students from across the campus enroll in drama courses. "Beginning Acting" utilizes scenes from

Black American plays to pidgin English or Creole plays about Hawaii's many ethnic groups. In the more advanced acting classes, students are introduced to contemporary plays and American and European classics. Students are assigned roles on the basis of the acting challenge, not of students' ethnicity. Both drama and music presentations reflect multiracial casting as a matter of course. Dance, an integral part of the many cultures that compose Hawaii, is likewise diversly reflected on campus. The Hawaiian studies department, while not a part of the performing arts department, offers performance courses and research services to students, faculty, and community members of all cultures.

University of Maine at Augusta

The University of Maine at Augusta (UMA) is a regional, community-based institution in central and mid-coast Maine, specializing in offering courses and support services to students of all ages from a wide variety of educational and cultural backgrounds. A commuter university, the campus attracts many part-time, nontraditional students. Although UMA strives for quality in all of its academic offerings, the programs in jazz and contemporary music are recognized in northern New England as viable options to traditional, postsecondary music study. UMA's Bachelor of Music curriculum is designed to produce a music generalist who will be capable of succeeding in the world of entertainment. There are no majors in performance, theory, composition, education, etc. All students take the same music courses (with the exception of their applied music sequence) to meet graduation requirements. All graduates are to have basic working skills in performance, composition and arranging, pedagogy, and electronic media/synthesizers/computers. Through its 15-year history, the music program has served hundreds of students who might not have been admissable to traditional conservatories and colleges of music because of their lack of earlier formal training. Developmental music theory and performance

courses have been implemented; peer tutors have been trained; keyboard labs and computer centers provide opportunities for students to drill themselves in fundamental skills. These efforts, and the curricular philosophy, have prepared many students for music and music-related careers.

University of Maine at Presque Isle

The University of Maine at Presque Isle has an enrollment of just over 1,300 and is located in a community of approximately 33,000, including surrounding towns and nearby Loring Air Force Base. The university serves a diversity of ethnic and cultural groups, including a number of Native American nations residing in both the United States and neighboring Canada. Therefore, the university seeks ways to enrich the cultural environment of the citizens of its region. One such example was an artist-in-residence program. Allan Houser, a Native American, was invited to the campus to work and display his art. The goals of the residency were: (1) to bring fine art to a university and region where such is not readily available or easily accessible; (2) to extend a special outreach to local and neighboring Native Americans by demonstrating the university's interest in and respect for their cultures and customs; (3) to have a special exhibition on campus during the week of the inauguration of the university president; and (4) to draw attention to an artist and Native American of international reputation who has made a contribution to society. Activities associated with the exhibition included field trips by area schools, meetings between the artist and local Native Americans and the general public, courses and lectures for university students, and a private showing and lecture for community leaders and others. The residency achieved its multiple purposes and the campus and the region were the richer for it.

University of Maryland, Baltimore County

The University of Maryland, Baltimore County (UMBC) is the

newest campus in the University of Maryland system. Located six miles from downtown Baltimore, it serves over 7,000 students. In addition to offering a wide array of curricula in the arts, the campus seeks to serve its community through the arts. Shakespearean productions, common in many cities during the summer months, have hitherto only been available to audiences in the Maryland area on a sporadic basis at a few college and community theaters. In an effort to reach a greater audience and enrich the cultural climate of its region, UMBC, in 1985, inaugurated a project entitled Shakespeare on Wheels. Using a portable replica of an Elizabethan stage mounted on a 40-foot flatbed trailer, students toured the region with "A Midsummer Night's Dream." Since then, Shakespeare on Wheels has proven its ability to bring live theatrical productions of professional quality to audiences at school athletic fields, parking lots, community parks, and shopping centers from the affluent suburbs to the poorer inner-city neighborhoods. The project has more than quadrupled its performance schedule, and has reached a large number of people who had never before seen a Shakespearean play. While reaching new and underserved audiences, the project also addresses the educational needs of theater students through their experiences in acting, staging, costuming, and managing. Begun with university funds, the project now charges host sponsors, such as community associations, arts councils, shopping centers, recreational councils, and others, a minimal booking fee. In this way, the performances remain free to the public.

University of Montevallo (AL)

The University of Montevallo (UM) is a state university enrolling some 2,600 students. Although most of them are from Alabama, others are from 25 states and 14 foreign countries. UM is a liberal arts institution with a career orientation. One goal of the university is to provide opportunities for personal enrichment for all of its students through involvement in the arts. Fine arts majors, while concentrating in their choice of artistic disciplines

in music, art, and communication arts (theater and mass communications), receive a firm foundation in the liberal arts. All university students are required to take an integrated arts course as a part of their general education. This course encompasses music, visual arts, and theater. Though located in a small university, the quality of the arts at UM has long been recognized by accrediting agencies. And the institution has had one winner and two nominees for the Irene Ryan Award at the American Theatre Festival in Washington, D.C.

University of Nebraska at Omaha

Founded as a private institution in 1908, the University of Nebraska at Omaha (UNO) became part of the University of Nebraska System in 1968. The nine colleges of the university offer students comprehensive programs in more than 100 majors and areas of specialization. UNO's 15,000-member student body reflects the diversity of Nebraska's largest metropolitan area. Some 80 percent of the students work while attending classes; six of every ten students are older than the "traditional" student. Initiated in 1972, the college of fine arts is the most recently organized college on the UNO campus, and the only college by that name within the UN System. It is composed of departments of art, dramatic arts, and music, the Fine Arts Press, and the Writer's Workshop. In addition to the traditional bachelor's degree offerings, a Bachelor of Science in Music Merchandising is a part of the curriculum. The college, within its metropolitan setting, seeks to enhance and expand the cultural climate of the community though collaborations with other arts organizations or through new, additional cultural offerings. It does this while providing its major students with a thorough grounding in arts theory and practice along with numerous opportunities for performances and practical experiences. Toward this latter element, the college of fine arts and the college of business administration developed a course entitled "Arts and the Executive." This graduate-level course, for business administration

and fine arts students, enables students to develop an expanded knowledge and appreciation of the cultural contributions of the arts to their community and helps to develop an awareness of the managerial issues confronting arts organizations. Taught by faculty from both colleges, professional artists, and arts management personnel, the focus of the course is to integrate the creative disciplines of the arts into the scholarly development of the business student and to transfer management theory and practice to the fine arts student. During the spring semester, the course is expanded and offered to business executives in the Omaha community. The course was recognized in 1987 by the American Association of Collegiate Schools of Business with its $10,000 Exxon Award for Excellence in Innovative Graduate Education.

University of Nevada, Las Vegas

Founded in 1957, the University of Nevada, Las Vegas (UNLV) educates some 6,000 students on a campus (mostly constructed since 1970) just a mile and a half from the Las Vegas Strip. Soon after the founding of UNLV, the board of regents designated the arts, together with geology, biology, and hotel management, as areas deserving special attention. Over the ensuing quarter century, UNLV's fine and performing arts have developed into vigorous, quality programs. The university offers majors in art, dance, theater arts, music, film studies, creative writing, and television. There is also an extensive array of courses for the general student body. The arts at UNLV have made the campus the cultural center of southern Nevada and their impact reaches far beyond the classroom. Concerts, performances, and exhibitions form the core of the cultural life of the community. The Master Series of musical performances and the Nevada Institute of Contemporary Arts are integral parts of UNLV's arts programs. Affiliated groups, including Nevada Dance Theatre, Nevada School of the Arts, and the Las Vegas Symphonic and Chamber Music Society, are located on the campus. The arts

were recognized and strengthened in the 1986-87 academic year by the university president's designation of "The Year of the Arts," a program designed to generate additional support for all the arts on campus. Private and corporate funds were sought to advance the arts at UNLV even farther and faster.

University of North Carolina at Asheville

Today, after more than 50 years of service to the people of western North Carolina, the University of North Carolina at Asheville (UNCA) has become a campus where faculty, curriculum, size, setting, and cost mesh for an exceptional liberal arts college experience. The arts—art, drama, and music—are important elements in the campus environment. In addition to offering degrees to arts majors, the arts faculty serves the entire student body. Included in the general education requirements for all students is "ARTS 310: Arts and Ideas." This course is an interdisciplinary team-planned and team-taught course that examines the various arts as products of human thought and responses to the human condition. The course investigates the materials and selected masterworks of the various arts of drama, literature, music, and the visual arts in order to illuminate certain basic issues and ideas. This required course is taken by all UNCA students during their junior year. In addition to the three-hour lecture course, consisting of lectures, performances and exhibitions, readings, and small discussion groups, each student must also enroll in a one-hour laboratory in one of the arts areas. This combination of approaches results in students having a broad, but intensive experience with the arts.

University of North Carolina at Greensboro

The University of North Carolina at Greensboro (UNCG) serves over 9,000 undergraduate and graduate students in the arts and sciences and professional and preprofessional fields. It has a long-standing commitment to the liberal arts and a historic commitment to teacher education. An influential aspect of the

teacher education program is the structure in which the pro-grams for teacher education in the arts and other disciplines reside primarily in the academic department of that discipline. The programs are guided by a coordinated, all-campus approach to teacher education policy and program development. To ensure success in this effort, each discipline has a Teacher Education Area Committee, the chairs of which form the Teacher Education Coordinator's Cabinet. A Coordinator of Teacher Education administers all of these activities. Among the strongest programs are those in art, music, and dance. In those disciplines, both at the undergraduate and graduate levels, students are as im-mersed in their art as those students who are working toward performance or studio degrees. The result is graduates who are artists/teachers who assume educational and artistic leadership roles throughout the region.

University of North Carolina at Wilmington

The University of North Carolina at Wilmington (UNCW) is situated midway between Wilmington and Wrightsville Beach, one the state's leading coastal resort areas. The university is a rapidly growing institution with a current enrollment of more than 6,000 students. One of the youngest campuses among the 16 in the University of North Carolina System, UNCW was established to provide educational opportunities through teach-ing, research, and service. Among the many areas of the arts found on campus is the UNCW Jazz Program, comprising an assortment of courses in performance, literature, and pedagogy. These courses presently fall under the rubric of music electives and are not required in any major. The most visible aspect of the program is its ensemble program, which includes the 7:00 Jazz Ensemble, the Jazz Fusion Group, and the award-winning Jazz Combo. In addition to campus performances, these groups appear at jazz festivals throughout the country. In 1987, the Jazz Combo was a national finalist in the First Annual Musicfest U.S.A. Festival hosted by *down beat* magazine; a UNCW student

received an All-Star Soloist Award for exceptional performance in the festival. In addition, the UNCW Jazz Program hosts an Annual Guest Artist Festival and Concert. Some of the most significant names in jazz have been guest artists. Each festival begins with a clinic by the guest artist, followed by his or her critiques and comments on performances by participating high school and college jazz ensembles. The finale of the festival is a gala concert featuring the guest artist with the UNCW jazz ensembles. This festival, and the entire jazz program, serve the student musicians well, provide excellent jazz performances for the student body and community residents, and help cement relations between the university and its colleagues and constituents.

University of North Florida

The University of North Florida, a regional university located in Jacksonville, serves northeastern Florida. It began operation in 1972 as an upper-level institution offering instruction at the junior, senior, and graduate levels. The department of fine arts was among the several departments organized at the opening of the school. Its primary mission was to serve majors from other departments as well as to provide majors in voice, piano, painting, and ceramics. The majors were soon expanded to include graphics and instrumental music. In 1986, the department was privileged to acquire an Eminent Scholar through the generosity of Mr. Ira McKissick Koger. With that endowment, an American Music Program was begun with a jazz studies program. Jazz educator and jazz euphonium artist Rich Matteson was named Koger Eminent Scholar of American Music to coordinate the jazz program. In its initial year, 40 students from around the states enrolled in the program. Two large jazz ensembles and four combos were developed. The Dixieland Band won the 1988 Southern Comfort -National Association of Jazz Educators Dixieland Band Competition and has placed in other competitions.

University of North Texas

The University of North Texas (UNT) will celebrate the centennial of its founding in 1990. Its evolution from a normal school to a comprehensive research and graduate university has culminated with its transition from North Texas State University in May 1988. UNT has 13 percent of its enrollment and 16.5 percent of its teaching personnel dedicated to the arts. Moreover, because of its location within the Dallas-Fort Worth metropolitan area, it offers significant opportunities for interaction with and cultural enrichment through the larger arts communities. Fine arts at UNT exist in two very different formats. Dance, theater, radio-television-film, and visual arts are part of the college of arts and sciences, which offers a rigorous liberal arts undergraduate core curriculum as well as a Classic Learning Core built on a private school model of an integrated humanities and social sciences curriculum. Within that liberal arts framework, the fine arts have the flexibility to develop professional programs. Each major area has some unique aspects. Professional preparation in interior design and advertising art is the most influential aspect of the visual arts. In general the art program is increasingly career oriented and has become one of the largest in the nation. Dance and theater are combined into one division, with theater productions including both contemporary and classical works, while dance performances emphasize contemporary works. A special emphasis is placed on touring companies in both dance and theater. The division of radio, television and film emphasizes professional training and operates a radio and television station. The film program is more oriented toward film criticism, although production courses are offered. Music is a freestanding professional school with a strong performance orientation and is probably the most nationally visible program at the university. Its musical groups have won national and international honors, and the school draws students from throughout the world. The music library contains collections varying from Arnold Schoenberg's compositions to the music of Stan Kenton. All these endeavors

serve at least four constituencies: the young artists who receive training that makes them competitive in the professional world; the general student population that benefits from the diverse cultural enrichment opportunities offered to them; the community, through the contributions of the university to the cultural life of the city; and the metropolitan community, which is similiarly enriched.

University of Northern Iowa

The University of Northern Iowa (UNI), located in Cedar Falls, is a comprehensive university of undergraduate and graduate programs in the colleges of education, humanities and fine arts, natural sciences, social and behavorial sciences, and the school of business. NIU offers much in the arts to the campus and community. Two special programs are the Theatre in Education and the *North American Review*. As one of the nation's oldest and highly regarded programs for creative drama, theater for children, and theater education, the theater program of UNI has been a nationally prominent innovator in the development of Theatre in Education (TIE), a program of group-generated, improvised drama about social concerns performed in educational settings. Unlike some traditional creative drama programming, the TIE program develops a script based on a social problem or concern through improvisation among a group of actors. The team then develops educational materials to precede, accompany, and succeed its appearance in school. Classroom teachers prepare the audience for the performance; TIE members then visit classrooms to lead discussions and evaluations of the problem or concern. TIE productions have been built on the law and ethical behavior, the U.S. Constitution, emotional abuse and self-concept, and other topics. Another exemplary aspect of the arts and humanities at NIU is the *North American Review (NAR)*, America's oldest literary quarterly. Founded in Boston in 1815 and published with only one interruption since that time, *NAR* was purchased by UNI in 1968. *NAR* has become one of the country's

most prestigious publications, honored for its essays on environmental topics and expecially honored for its fiction, twice winning the National Magazine Awards (the Pulitzers of the magazine world) and six times designated a finalist in that competition. Writing from the *NAR* is regularly reprinted in *Best American Short Stories, Best American Essays,* and the yearly O. Henry anthologies. Among the authors the magazine has encouraged early in their careers are George V. Higgins, Barry Lopez, Joyce Carol Oates, Raymond Carver, and Bobbie Ann Mason. *NAR* has a circulation of 4,500 (including 1,200 libraries) and an estimated readership of 25,000 people. These two ventures enable NIU to serve its region and the nation.

University of Pittsburgh at Bradford (PA)

The University of Pittsburgh at Bradford (UPB), a four-year college of the University of Pittsburg, was founded in 1963. It is located near the Allegheny National Forest in northwestern Pennsylvania. The population of the Bradford region is approximately 25,000; the campus enrolls some 1,000 students. In a community with no art museums, theaters, or music halls, the campus has become the cultural center of the Bradford area. One important way in which this is accomplished is through the Humanities Spectrum Series. Spectrum offers a variety of cultural events of an educational nature to the UPB campus and the Bradford community, usually at no cost. Through Spectrum, lecturers, artists, and performers of both regional and national reputation provide serious perspectives on art, literature, philosophy, theater, and other performing arts. Additionally, an annual art show is sponsored. Whenever possible, Spectrum events are linked to curricula and programs.

University of Puerto Rico, Humacao University College

Situated on the East coast of the island of Puerto Rico, Humacao University College (HUC) is an institution that has for some time given more emphasis to science and technology than

to the arts. Yet the university has recently realized that the arts—as well as the liberal arts—should not have been diminished, because too many young professionals today often lack the cultural and artistic sensitivity that is appropriate for a university graduate. Therefore, although HUC has not yet offered a B.A. in the humanities, the humanities department has tried to remedy this deficiency by widening its curriculum and offering an attractive cultural activities program. The arts course offerings include music, theater, and visual arts, including a course on the arts in Puerto Rico. This is especially significant, because many citizens of Puerto Rico are not completely aware of their history, culture, and artistic values. In addition to classes, music performing organizations (choir and band) and a theater group provide experiences to many students, most of whom are not arts majors. Although the curricula and performance groups include music and theater from an international base, the arts of Puerto Rico are noteworthy. The university takes these cultural offerings beyond the campus, especially into elementary schools, to help young people understand, at an early age, the culture of their country and the world.

University of South Alabama

Located in Mobile, the University of South Alabama is a comprehensive university offering programs to some 7,800 undergraduate and graduate students through seven colleges, including the college of arts and sciences. Within that college are the departments of art, music, and drama. This latter department, lacking a campus theater, is resourceful in utilizing cafeterias, ballrooms, and dormitories on campus, a local high school auditorium, a community theater, and a university-owned, converted, old Vaudeville house in downtown Mobile. Selecting productions that can be presented in these settings requires skill, but the department presents at least one major production each quarter, a classic with matinee performances for high school students, and an annual children's show. These

shows, and the difficulties of staging them, help create talented, skillful, and adaptive students. But the production schedule doesn't overshadow the curriculum. It is solid and demanding, with a required Senior Thesis, in which the student develops a major project and writes a paper about the project. The program also requires a Theatre Practicum, in which the student works full time in an off-campus theater job for one quarter.

University of Southern Maine

The University of Southern Maine (USM), with campuses in Portland and the neighboring town of Gorham, a faculty of 290, and an enrollment of over 9,000 students, is the principal public higher education institution in the most populated and fastest-growing part of the state. As a part of its outreach program to the region, the university has sponsored the Stonecoast Writers' Conference for the past nine summers. The conference, for students selected by review of manuscripts, offers writing classes, lectures, and literary presentations by USM writing faculty and invited guest writers. The summer workshops cover poetry, fiction, and the novel. The two-week program, in addition to the instruction, allows time for students' intensive writing and for individual manuscript conferences with faculty. Readings and lectures are open to the public, thus enriching not only the participants but a larger regional audience.

University of Southern Mississippi

The University of Southern Mississippi (USM), founded in 1910, is one of the state's eight public universities. Over 10,000 students are served by a wide array of programs in 14 academic units. The college of fine arts serves both as an educator of young professionals and as a cultural resource of the community. Cooperation between the campus and the community is a hallmark of the university. One of the most interesting and effective new developments in the arts program of the USM has been the establishment, in cooperation with the Hattiesburg Civic Arts

Council, of a series of professional guest artists. After a decade with no less than three series of professional concerts in a city of some 40,000 residents, it had become obvious that there was neither enough money nor audience to continue such a pattern. Several successful meetings were held that culminated in the public announcement of the new series under joint sponsorship of the university and the council. Excellent media coverage was provided, with the actual signing of the Articles of Agreement covered by commercial television and the newspaper. Attending the event were the mayor, president of the university, president of the arts council, dean of the college of fine arts, and other interested townspeople. The renewed and reinforced atmosphere of cooperation between the city and the university may ultimately prove to be as valuable as the improved quality of the artist series.

University of Tennessee at Chattanooga

Founded in 1886 as a private, church-related college, University of Tennessee at Chattanooga (UTC) became a part of the University of Tennessee system in 1969. Today, it serves some 6,000 students through programs in the college of arts and sciences and the schools of business administration, education, engineering, human services, and nursing. A new and unique feature of the arts at UTC is the Southeast Center for Education in the Arts, which includes the Southeast Institute for Education in the Visual Arts, the Southeast Institute for Education in Theatre, and the Southeast Institute for Education in Music. The center, through its institutes, provides a discipline-based approach to arts education. This discipline-based approach to teaching emphasizes history, criticism, and aesthetic qualities of art, as well as production and performance. The center assists public and private, elementary and secondary schools in developing arts education curricula in theater, music, and the visual arts. It accomplishes this task through summer institutes, year-round workshops, teaching assistance, and resources. It reaches teachers and principals from 15 school districts in southeastern

Tennessee, northwestern Georgia, and northeastern Alabama. The center also seeks to link schools to community resources and agencies, build community support for arts education, upgrade high school graduation and college entrance requirements, and enhance teacher certification standards. Funds to support the center and its activities come from the Lyndhurst Foundation, the Getty Center for Education in the Arts, the State of Tennessee funds for a Chair of Excellence in Arts Education, private donors, and UTC.

University of Texas at Dallas
 The University of Texas at Dallas is an upper-division, nonresidential university offering bachelor's, master's and doctoral degrees. The university is located in Richardson, a suburb of Dallas. The school of arts and humanities is an interdisciplinary school, and courses are designed to draw from a variety of disciplines in order to investigate the linkages between the arts and the humanities. Although there are no departments, undergraduate students choose either arts and performance, historical studies, or literary studies as a primary field. Graduate students may emphasize aesthetic studies, history of ideas, literary studies, or humanities. However, all students must take courses in disciplines outside their major field. The arts play a central role in all areas of study. Since there are no departments, students from all disciplines study performance, theory, and art and are encouraged to take part in the creative process. Studio and performance courses are not designed to produce mainstream artistic products. Rather, they attempt to challenge students to extend themselves beyond traditional aesthetics to create works of art that challenge accepted tenets. As such, theoretical, historical, and practical aspects of the creative process are emphasized equally. Specifically, curricular programs tend to emphasize modern and postmodern artistic theory and practice that give rise to unique projects. Visiting artists, productions, exhibitions, and festivals reflect this philosophy. Obviously, a

program committed to such goals will not attract traditional audiences. However, the school of arts and humanities is considered by critics, artists, and performers to be a center for progressive, innovative, and creative work.

University of Texas at Tyler

The University of Texas at Tyler is an upper-level and graduate academic component of The University of Texas System. The new campus, just 10 years old, enrolls some 3,700 students with a faculty of nearly 200. The university is organized into four schools: business administration, education and psychology, liberal arts, and sciences and mathematics. The school of liberal arts consists of departments in art, drama and communications, humanities, music, and social sciences. The fine and performing arts have a critical need for instructional, studio, performance, and exhibition space. Currently, most instruction is ongoing in standard classrooms. Even so, the fine and performing arts have had a significant impact on the campus, thanks to a dedicated faculty and a relatively young support group, The Friends of the Arts. Begun in 1985, the Friends group has become a most influential and positive force for the university and the entire region. This is an organization of artists, scholars, patrons of the arts, and benefactors whose purpose is to support the arts. Their intent is twofold: (1) to support the university in its efforts to bring noted artists to the campus and (2) to assist in providing for those special needs that enhance the academic programs in the arts. These goals are realized in a number of ways, such as distinguished lectures in art history, the underwriting of an opera appreciation course, the development of library resources and art history slides, and a scholarship program. The Friends of the Arts will undoubtedly play a pivotal role in efforts to secure funding from many sources for the building and equipping the aforementioned needed facilities, thus allowing East Texas to realize its full potential in the arts for its campus and community constituents.

University of Texas of the Permian Basin

The University of Texas of the Permian Basin is a small, young, upper-level and graduate institution located in Odessa, a city of 100,000. Except for a comparably sized sister city, Midland, some 20 miles to the east, Odessa is located away from urban centers. Therefore, the cultural life of the two areas is generally home grown. They share a symphony, each has a civic theater, and Odessa, with its replica of the Globe Theater, a yearly Shakespeare festival. Support, however, comes from a relatively small percentage of the residents of the cities. This obstacle to the success of the arts at UT Permian Basin, shared no doubt by some other colleges in the country, is compounded by a situation almost unique to this institution. As an upper-level university, UT Permian Basic cannot offer freshman and sophmore courses. The "two-plus-two" structure urges students to complete their lower-division work at a junior college and transfer to the upper-division institution for final work. Education in the arts is as much a mentoring process as a sequence of courses, so students often find the transfer a less appealing prospect and enroll initially in a four-year institution. To address this problem, UT Permian Basin is exploring two possible solutions. One proposal is to make joint appointments in music with Odessa College, the local community college. In this concept, faculty at the community college who possess the appropriate academic credentials could join the university faculty. This venture could allow for greater continuity in coursework and teacher/mentor tutoring, could break the artificial barriers of lower- and upper-level faculty, could allow the students access to a more extensive and expansive curriculum and programs, and could provide a more stable foundation for a host of music activities in the region. A second proposal is to create a University College, a select group of students for a rigorous, specific, liberal arts experience. This honors program would be taught by faculty from UT Permian Basic and Odessa College. Should these ideas be implemented,

they could prove to be an interesting model for university and community college cooperation.

University of Wisconsin-Oshkosh

The University of Wisconsin-Oshkosh is the third largest university in the 13 institution University of Wisconsin System. The university has four colleges: letters and science, education and human services, nursing, and business administration. The largest of these is the college of letters and science, which enrolls some 5,200 students in three divisions encompassing 24 departments. The departments of art, music, and speech (including theater and radio/televison/film) are part of the humanities division. In addition to providing education for the major students, the departments of the arts provide numerous arts offerings to the campus and the community. These offerings include the Chamber Arts Series, which brings internationally known musicians to the campus; the Frederic March Theatre season, which includes 5-6 student productions, a faculty production, and one professional production; and the Priebe Art Gallery, which presents student, faculty, and visiting exhibitions. Consistent with this mission, and as one example of university outreach, the faculty of the music department established the Faculty Chamber Music Concerts. One important goal of these concerts is to raise scholarship funds for music students. These concerts present a wide range of instrumental and vocal music, from early eighteenth century to contemporary, to numerous university and community audiences. They are successful in fund raising, in providing faculty a forum for recognition, and in enriching the campus/community cultural atmosphere.

University of Wisconsin-Platteville

Established in 1866, the University of Wisconsin-Platteville serves over 5,300 students in the areas of agriculture, education, engineering, management, music, and social science. In addition to offering curricula in the arts, the university serves as the

cultural center for the community of some 10,000 people. A hallmark of the arts at the university is the Wisconsin Shakespeare Festival, an annual two-month, summer celebration of Shakespearean and other classical drama. The festival takes place in UW-Platteville's Center for the Arts' Studio Theatre. Founded in 1986, the festival is a nonprofit, nonunion professional theater company designed to provide a rotating repertory of three plays by a nationally recruited company of actors. The company is recruited primarily from professional theater training programs from all over the United States and from the pool of practicing professionals. The festival consists of 32-38 performances. Now in its twelfth season, the festival has staged 21 of Shakespeare's plays and played to over 55,900 spectators. About 37 percent of the audience is from Platteville, the balance from other parts of Wisconsin, Iowa, Illinois, and elsewhere. In conjunction with the festival, the university's English department offers an annual summer workshop in which each play is studied in depth. A similar program is offered by the Elder Hostel, the Teen University, and the College for Kids. Plans for the future include expansion of the festival into late August and September so that its educational purpose may be better fulfilled in special matinee performances for elementary and secondary schools. The festival would not be possible without significant funding. In addition to the university's support, funds from the Wisconsin Arts Board, foundations, corporations, and patrons have been secured. The chamber of commerce actively promotes the festival.

University of Wisconsin-Stevens Point

The University of Wisconsin-Stevens Point is situated on a rural campus 110 miles from Madison. Serving over 9,000 students, the university offers programs in the arts and sciences and in an array of professional and preprofessional fields. The college of fine arts and communication has existed for over two decades and is one of only three colleges of the arts on the 13 campuses within the University of Wisconsin system. One of four

academic units at Stevens Point, the college has approximately 1,200 majors in the departments of art and design, communication, theater arts, and music. Additionally, the college sponsors two precollegiate programs, the Conservatory for Creative Expression and the American Suzuki Talent Education Program. Five years ago, the college undertook a major review and revision of its curricula. The result is competency-based curricula intended to challenge the individual talents of students. Students may elect a liberal arts degree or a professional degree program. To the more traditional areas of arts specialization, the college has added nine new areas: jazz/commercial music, technical theater, choreography, design photography, graphic design, environmental design, computer graphic design, musical theater, and arts management. Believing that universities have a commitment beyond the classroom, the college assumes social and cultural responsibilities in the region. As a result, over 200 curricular-related and outreach fine arts offerings serve 75,000 people each year.

Valdosta State College (GA)

Valdosta State College, a senior college of the University System of Georgia, is located in the south-central area of the state. South Georgia is a region with a history of economic and cultural disadvantage. Although progress has been made over the past few years, the more rural parts of the state have not benefited adequately from those endeavors. Social and governmental organizations, including educational institutions, have much opportunity and heavy responsibility to effect and support positive change. Valdosta State eagerly accepts this responsibility, not only in economic and social endeavors, but also in artistic and cultural efforts, to enhance the quality of life of the region. The school of the arts, the only such administrative unit in the university system, includes art, speech communication, theater, radio, television, and music. The school has implemented a development plan, consisting of three parts and designed to guide

the evolution of the collegiate instruction programs toward creation of a Center for the Arts for South Georgia. First, the arts disciplines serve student-clients at a level capable of producing professional artists and communicators. Second, the natural products of a professional level training program are taken to every community in the area to enrich the cultural climate of the region. Third, the civic, governmental, and educational institutions of the region are offered advice, logistical support, and personnel services in developing local programs of artistic involvement and instruction.

Virginia Commonwealth University

Virginia Commonwealth University (VCU) enrolls some 19,800 undergraduate, graduate, and health professions students on its two campuses in Richmond. The city is rich in the arts; VCU both contributes to and benefits from that cultural environment. The school of the arts at VCU enrolls some 2,500 majors and is the third largest art school in the United States. It has continually strengthened its long-standing commitment, as an urban university, to serve the community at large. For example, it schedules more than 380 exhibitions and performances by students, faculty, and visiting artists each year. Among the most outstanding of the performances are those of the Terrace Concerts, initiated in 1984 in conjunction with the Kennedy Center for the Performing Arts in Washington. There are university/community collaborations in theater, music, dance, and visual arts. To further serve the community and region, VCU offers noncredit instruction to more than 2,000 students annually, in 11 counties as well as Richmond, through its Community School of the Performing Arts. Additionally, the school of the arts offers professional-quality design work to nonprofit organizations through its Design Center, a part of the department of communication arts and design. As further evidence of its dedication to the arts and to the community, it provides transportation for senior citizens to its performances. It has administered the Governor's

Summer Regional High School as part of the Governor's Center for Educational Innovation and Technology Project. The school sponsors, through its department of fashion, an annual fashion show and dinner for an audience of some 800 people. In conjunction with the City of Richmond, it sponsors an annual jazz festival. The school's department of communication arts and design places more students in part- and full-time employment positions (through VCU's cooperative education program) than any other department of the university. Finally, the VCU department of music and the City of Richmond produced the Richmond International Festival of Music, in which approximately 300 performances and master classes were offered in 38 locations over a three-week summer period.

Wayne State College (NE)

Wayne State College (WSC) is a small college located in Wayne, a community of 35,500 residents near Omaha, Lincoln, and Sioux City. In addition to offering degree programs in a variety of arts fields, the college has become a cultural resource for the community and region. For example, the Plains Writers Series, now in its eleventh year, brings writers of national or regional prominence to the Wayne State campus. During the time on campus, the writers speak to writing and literature classes, confer with individual writing students, and present readings of their own work. This program has brought over 60 writers to the campus. The writers chosen usually represent both the perspective of the Great Plains and the larger world, thus giving WSC students and the community a sense of the larger world, without denigrating their own, and connecting them with the universality of the human experience. In another writing venture, the division of humanities has assumed the major role in planning and sponsoring the annual Neihardt Conference held in honor of Nebraska's poet laureate. Respected speakers have addressed such topics as the American theme of the journey to self, the uses

of the oral tradition, and the classical elements in the work of John G. Neihardt. In these and other ways, WSC attempts to move the arts and humanities out of the classroom and into the world.

West Georgia College

West Georgia College is a regional senior-division unit of the University System of Georgia. Located in Carrollton in one of Georgia's fastest-growing areas west of Atlanta, the college enrollment nears 5,000 students. To complement its curricular offerings in the arts and to expand the artistic opportunities for students, faculty, and individuals from the community, the college has an Artist-in-Residence program. A noted artist is brought to the campus for one quarter in which he or she teaches one class and works in an open studio for at least eight hours, giving students the opportunity to work side by side with the professional. On leaving the campus, the artist leaves a work of art. Past artists have included Shiro Otani, Japanese potter, who built a wood-firing anagama kiln on campus. Otani also gave the city of Carrollton a pot on the anniversary of the bombing of Pearl Harbor. The program is supported by the college and the West Georgia Foundation.

West Texas State University

West Texas State University (WTSU) is a comprehensive institution of 5,700 students in Canyon, 15 miles from Amarillo. It is essentially an urban university serving Amarillo and the Panhandle region. The arts are integral to the university and to the surrounding area. WTSU, in fact, is the source of much of the strength of the arts of the region. For example, the division of music supplies all of the principal players for the Amarillo Symphony as well as 50 percent of the symphony's complement. The *corps de ballet* of the Lone State Ballet consists almost

entirely of university students. Teacher education is a strong element of the department, with influences regionally, statewide, and even nationally. Some 70 percent of all music educators in the Panhandle are graduates of WTSU.

West Virginia State College

West Virginia State College (WVSC), located in the state's center of government, industry, business, and population, serves as a major resource for the metropolitan area of Institute. The college's primary mission focuses on strong baccalaureate degree programs in the arts and sciences and in professional studies. It also offers services to the adult/nontraditional student. Founded in 1891, the college attained national prominence as an institution of higher education for Blacks, and among other specialties, it continues to serve as a center of Black culture. Voluntary desegregation in 1954 created a distinctive "living laboratory of human relations," attracting a racially and culturally diverse student body, faculty, and staff. The college cherishes its unique history and its reputation for safeguarding academic freedom, for being innnovative in its scholastic programs, and for removing barriers to education and leadership for women, minorities, and the handicapped. WVSC's location and diverse populations served have caused the college to provide cultural opportunities that might not otherwise be available to those constituents. Toward this end, the college has a Committee on Cultural Activities, which provides opportunities for students, faculty, and the community to attend performances and lectures in the areas of music, art, drama, and film. Each month, two or more artists are on the campus. Such artists and groups as Alvin Ailey, Stan Getz, and the Soviet Emigre Orchestra have enriched the campus. Lectures by James Earl Jones, Tony Brown, and Maya Angelou have enlightened audiences. The art gallery has been the site of numerous traveling and local exhibitions. These efforts are supported by student fees, the West Virginia Arts and Humanities Division, The Department of Culture and History, and The

Humanities Foundation of West Virginia. By working with a consortium of statewide presenters, the college utilizes block bookings to secure events that might not otherwise be affordable for small communities and colleges.

Western Carolina University (NC)

Western Carolina University (WCU) is located in the scenic Appalachian Mountains at Cullowhee. A faculty of 300 serves a student body of about 6,200 in resident credit and extension courses. WCU consists of six schools offering bachelor's, master's, and education specialist degrees. As a cultural center for the region, the university's department of music offers a wide spectrum of musical experiences for students and for the public. The Cullowhee Music Festival is an annual two-week event featuring professional orchestra concerts, an opera, a musical theater production, numerous chamber music events, solo recitals, and either chamber music or solo instrument competitions. The summer of 1988 was the fourteenth consecutive year of the festival. Each year the festival features artists-in-residence who perform with the orchestra or in other musical events. The artists-in-residence also serve on the adjudication panel for the competitions of the festival. A primary goal of the festival is cultural outreach. Festival groups regularly perform in surrounding communities and are supported in part by local arts councils. The continuing aim is to provide excellent and diverse musical experiences for campus, community, and regional audiences.

Western Connecticut State University

Western Connecticut State University (WestConn) is located in Danbury, some 65 miles from New York City, adjacent to the New York state border. The university, which enrolls 6,000 students, is organized into three schools: arts and sciences, professional studies, and the Ancell School of Business. Located on two campuses, one midtown and the other in the rapidly

growing corporate region, the university seeks to meet the increasing demands for education and cultural activites. West-Conn has a history of involvement with the community, not only through its academic and business programs, but through its willingness to serve as a resource to the community, especially in the arts—drama, visual arts, and music. The university hosts performances, festivals, master classes, and exhibitions for the campus and the community. The most successful arts venture in this region is the collaboration between the university and the Charles Ives Center for the Arts. The Ives Center, founded in 1975 by business and cultural leaders, began to flourish when the university provided a home to the center in 1980 by leasing 39 acres of land on the Westside campus for outdoor performances during the summer and early fall. Long-range plans for the Ives Center include construction of an arts center for year-round performances, classes, exhibits, and a variety of other uses by arts groups and educational organizations. Many of the summer performances—which have included such groups and individuals as the American Symphony Orchestra, the Preservation Hall Jazz Band, the Canadian Brass, Isaac Stern, Jessye Norman, Ray Charles, and Julius Rudel to name a few—have attracted audiences of 5,000-10,000 people. The university benefits from the presence of the Ives Center on its campus through the widespread publicity of the performances and the influx of large audiences who visit the center and campus. The university and the community benefit from the enriched cultural climate the center provides.

Western Illinois University

Western Illinois University is located in Macomb, a town of 23,000, 40 miles east of the Mississippi River, and roughly equidistant between Chicago and St. Louis. The university enrolls nearly 12,000 students and has a faculty of nearly 650. The college of fine arts offers undergraduate and graduate degrees in music, art, and theater arts. The college has the dual mission of training professional artists and teachers and of

educating the general student and citizen population. One way in which the college addresses this dual mission is through a touring theater company. Formed in 1974, the company was designed to provide quality live theatrical experiences to the West Central Illinois region, and to provide a paraprofessional experience for graduate students in theater. It performs one children's play and one general audience play each semester, averaging 150 bookings during the nine-month period. The actors, stage managers, designers, and costumers are all students who receive credit through a career internship practicum. The company has played in elementary and secondary schools, senior care facilities, YMCAs, civic halls, town squares, granges, and community opera houses. In 13 years, there have been 1,800 performances, 55 different plays, half-a-million people in attendance, 400,000 miles traveled, and six tour vans exhausted. This has been a most successful way of providing theater students with practical experiences while enriching the lives of area citizens, particularly the young, the elderly, and the economically disadvantaged.

Western Kentucky University

Western Kentucky University (WKU) is located in Bowling Green, a small city of 50,000 people in a predominantly rural area of South Central Kentucky. Located between Louisville and Nashville, Bowling Green is the fifth largest urban area in Kentucky and provides retail, cultural, and professional services to several surrounding counties. But unfortunately, this region has not traditionally stressed education. Barely half of all Kentucky adults have a high school diploma, and in Warren County, where WKU is located, a quarter of the adult population did not attend school past the eighth grade. Many WKU students are not only the first in their familty to attend college but also the first to graduate from high school. Consequently, the consitituency for the arts is significantly underdeveloped. Within this setting, WKU has built a Performing Arts Center unique to the region. It consists of: (1) a full dance program with a dance

company, a youth preparatory program, and a summer training school for Dance Educators of America, a national organization; (2) a music department that has a faculty with regional, national, and international reputations; and (3) a theater program with a full production schedule, an extensive children's theater program, a musical theater program, and a semiprofessional dinner theater. These ventures have been successful because of the effective interaction among the participants. The programs provide students with the basic instruction and experience necessary for successful careers in the arts. This is evidenced by the many successes of WKU's alumni. At the same time, the programs of the Performing Arts Center contribute significantly to the outreach efforts of the campus as new audiences of young and older citizens are introduced to the arts.

Western Michigan University

Western Michigan University (WMU) is a large, comprehensive university offering baccalaureate through doctoral degrees. It is located in Kalamazoo, halfway between Detroit and Chicago. A leading city in the arts, Kalamazoo has a professional modern dance company, theater groups, an art institute, a museum, and a symphony orchestra as well as other musical ensembles. WMU's college of fine arts includes departments in music, dance, theater, and art; a wide array of degree programs are offered. In addition to the traditional courses and activities found in colleges of fine arts, WMU's college has an array of special projects. A Ballet Teaching Seminar (Russian Method) provides participants an opportunity to study with a distinguished international faculty. Programs are presented for teachers, intermediate and advanced students, and professional dancers. Another special project of the college is the High School Music Seminar, offered this past summer for the 37th consecutive summer. Over 150 high school students are selected by audition; they receive experience in large ensembles, chamber music, theory, history, and literature. The Music Performance Institute of WMU brings

world-class musicians to Kalamazoo for extended interaction with musicians, educators, students, and patrons. Master classes, classroom lectures, private lessons, pre-concert lectures, and special presentations are among the institute's programs. In a cooperative venture with Michigan's 15 primary arts associations, WMU hosts the Michigan Youth Arts Festival. After a year-long talent search, some 800 young artists in all artistic areas (selected from some 40,000 applicants) attend a 2-1/2 day festival of workshops, performances, and exhibitions. Finally, the college provides administrative support for the Plaza Arts Circle (PAC), founded in 1982 by community leaders in conjunction with WMU. Its objective is the enhancement of the arts environment of the Greater Kalamazoo area. The highest priority for PAC support is given to activities developed cooperatively among Kalamazoo's five institutions of higher education and/or its community arts organizations. These special activities, and others, greatly enhance WMU's curricular offerings for all its students and enrich the cultural environment of the region.

Western Oregon State College

Western Oregon State College (WOSC), located in Monmouth, serves as the cultural hub of the region. WOSC serves over 3,200 undergraduate and graduate students in a wide array of programs in the arts, sciences, and professions. It prepares students for professional and teaching careers in the arts through its creative arts division, which houses the departments of art, music, theater, and dance. WOSC complements its degree-granting programs with several unique outreach offerings to better serve arts education in the state. The Apple Box Children's Theatre (ABC) has presented more than 400 performances to thousands of mid-Willamette Valley children and adults since its first performance in 1979. ABC tours schools in biennial sessions with children's classics and new children's works. ABC also performs on campus for children's field trips. Another outreach effort is unique to Oregon: the Community School of the Arts was

established in 1986 by the college and the community. The self-supporting school serves talented youngsters in surrounding communities who desire instruction in the arts. Modeled after other successful community schools in the nation, the school offers group classes and private lessons. The school is housed in WOSC facilities and is staffed with WOSC faculty.

Another effort to assist arts education in the state is WOSC's efforts to help arts teachers by developing computer application programs. The first such program, developed by WOSC faculty and administrators, was an introduction to music. Configured as a user-friendly program, it uses the computer, a color monitor, a videocassette player, and a laser disc player to guide a student through a series of demonstrations of various music instruments. This program won the "Masters of Innovation" award by Zenith Data Systems, Chicago. Another program that is unique to the cultural education of the region is the Paul Jensen Arctic Museum. Housed on campus, the museum contains the rare 4,000-piece collection of Native Alaskan artifacts belonging to Dr. Jensen, professor emeritus. The museum features exhibits, displays, audiovisual demonstrations, and a "Diorama" room that brings the sounds and sights of the Arctic to life, enabling thousands of adults and children to better understand the life of the Eskimo people.

Western Washington University

Western Washington University (WWU) is located in Bellingham in the northwestern corner of the state, near Canada. WWU serves over 9,000 students in seven academic units. Among these are the college of fine and performing arts, formed in 1975 as the unit committed to the education, development, and performance of the fine and performing arts. Its facilities include a concert hall, a major theater, two experimental theater performance spaces, a small theater, rehearsal spaces, classrooms, art studios, and galleries. Recently completed, the Western Gallery complements the Outdoor Sculpture Museum, whose installations can be

found throughout the university's grounds and plazas. The outdoor collection, including works by Isamu Noguchi, Richard Serra, and Alice Aycock, is considered of international importance by the art world. In this environment the college serves its major students. While major students pursue a specific discipline, the college curricula enable them to learn and grow through developing interests in other artistic disciplines. For the general studies student, the college provides interdisciplinary arts courses as embarkation points into diverse arts explorations. Further, the college is the primary provider of arts events to the university community and immediate northwestern region through its presentations of festivals, visiting artists and artistic attractions, faculty and student performances and exhibitions, and master classes and workshops.

Wichita State University (KS)

The Wichita State University (WSU) is an urban university with a focused mission intended to meet the industrial, business, education, social, and cultural needs of the Greater Wichita area. WSU offers 185 academic majors in six undergraduate colleges with a total enrollment of 17,000 students. The college of fine arts contributes to the university's mission by delivering programs and cultural outreach in the visual and performing arts to the citizenry of the region. A hallmark of the college's desire to support cultural activity is its partnership with the Wichita Symphony Orchestra. This regional orchestra had its beginnings in 1944, and the relationship between the two organizations remains strong today. It has become known as The Wichita Plan. The cooperative effort permits the Wichita Symphony Orchestra to retain quality musicians for its approximately 50 concerts, playing for audiences totaling 175,000. The season consists of 10 pairs of classic concerts, three soiree performances, two pop concerts, and a young people's concert series. All of the principal players of the orchestra are faculty members of the school of music at WSU. The section players are mainly composed of WSU

graduate students, highly qualified undergraduates, and alumni. The associate conductor and two youth orchestra conductors are faculty members. Other aspects of the partnership include scholarships for university students; faculty/orchestra joint appearances; instruments, equipment, and music exchanges; and rehearsal space for the orchestra on campus. Therefore, The Wichita Plan has enabled the university to attract and retain quality faculty and students because of the opportunity to play in a reputable, regional orchestra; the faculty and staff have benefited from the appearance of guest performers; the regional visibility has provided many youth in the state with an important initial introduction to orchestral music; and the citizens of the region have an opporunity to hear and participate in a symphony orchestra.

William Paterson College (NJ)

William Paterson College is a hybrid institution: only three miles from the city of Paterson and 25 miles from New York City, it is located in a sprawling suburban area just 10 miles west of the foothills of the Appalachians. Consequently, the student body is a mixture of urban minority students with a predominance of white, middle-class students from suburbia. Most are first-generation college students who must work part time to support themselves. Students can find majors and courses in theater and communication, art, and music. One of the most significant major areas is the Bachelor of Music in jazz performance. Begun in the late 1960s, the major has become most prestigious, attracting students from all over the country and foreign nations. The strength of the program is its unique attention to small group improvisation. A distinguished cadre of outstanding jazz professionals from the metropolitan area constitute the majority of the faculty. Teaching sessions are intensive and offer a large measure of constructive criticism. Students are encouraged to perform publicly in small ensembles. Each year, ensembles travel to Notre Dame, Miami, and other places to participate in national jazz

festivals. For five consecutive years, a student performing group won the "Outstanding Combo Performance" award at the Notre Dame Collegiate Jazz Festival. A significant number of jazz majors transfer from other institutions. Auditions, for entering freshmen and transfers, are rigorous; the rejection rate is high. To ensure continuing quality, only 60 majors are permitted in the program at any one time. The success of the program can be recognized by the many alumni who have performance experience with such artists as Miles Davis, Lionel Hampton, Count Basie, and many other leading jazz groups.

Winthrop College (SC)

Winthrop College is located in Rock Hill, the geographic center of the two Carolinas. Within its academic units, more than 5,000 students pursue one of more than 50 undergraduate and 40 graduate degree programs. Based in the school of visual and performing arts, the arts are vital and important to Winthrop. The school was formed in July 1988 and includes music, art, dance, and theater. A major renovation and expansion was begun for the facilities of the department of art and design. As the new school organizes, curricular reform will likely take place. However, while internal reorganization takes place, the college does not forget the external aspects of its mission. Winthrop College is taking a leadership role in South Carolina as a pro-arts institution. Through leadership in the "Arts in Basic Curriculum Plan," Winthrop faculty are coordinating the development of a comprehensive sequential arts program in public education. Winthrop arts faculty serve on state and national boards and organizations, and they serve the needs of a large population of students, patrons, and teachers.

Youngstown State University (OH)

Founded in 1908, Youngstown State University (YSU) is located in an urban setting with a rural economy. This constituency presents unique opportunities in terms of university out-

reach efforts. One such endeavor is the Interface program, through which university resources and community resources mutually enhance one another. The Interface project in art produces the Symposia of American Art, through which the university art department cooperates with the Butler Institute of American Art. At least one lecture per quarter is presented, and special art exhibits are funded for display at the Butler. Artists, critics, and historians (e.g., Sam Gilliam, Paul Jenkins, Richard Hunt, David Shirey, Ivan Karp) make presentations. The diversity of viewpoints provides the audience of faculty, students, patrons of the arts, and the general public with stimulating and enlightening perceptions about the visual arts. The school of music's most successful efforts include collaborations with the Youngstown Symphony Orchestra and the public schools. Other linkage activities include the New Music Festival, Madrigal Fest, High School Choral Festival, and the like. In theater, the Wean Lectureships, Theatre Interface, and high school workshops have great impact. Interest in drama is greater in rural areas than in the blue-collar sections of the city. The university program relates most directly to the theater community in the Mahoning Valley, to the Youngstown Playhouse, and to other community-based organizations. The purpose of the Theatre Interface program is to facilitate the use of university theater resources to foster quality high school theater programs. Through newsletters, workshops, school visits, guest artists, and a theater festival, this program has assisted fledgling high school drama programs.

Afterword

This work supports the belief that the arts are vital components of our nation's culture. Colleges and universities are also essential elements in the nation's total environment. The arts on campuses mirror the arts of the nation; this book adds credence to the widely held belief that state colleges and universities form a healthy and invigorating home for the arts and a cultural core for their communities and regions. Thousands of young artists and arts enthusiasts are being educated on these campuses. Thousands more experience the arts through outreach programs. This rich and enriching climate for the arts bodes well for the present and future. An aesthetically sensitive, literate, and intellectually expansive population will serve not only the arts, but all of the endeavors of mankind.

Appendix A

Responding Institutions

A

Alcorn State University (TX)
Appalachian State University (NC)
Arkansas State University
Arkansas Tech University
Augusta College (GA)

B

Ball State University (IN)
Black Hills State College (SD)
Bloomsburg University of Pennsyl-
vania
Boise State University (ID)
Bowling Green State University (OH)
Bridgewater State College (MA)

C

City University of New York,
Lehman College
City University of New York,
Hunter College
City University of New York,
Queens College
California State Polytechnic
University, Pomona
California State University
California State University,
Bakersfield
California State University,
Dominguez Hills
California State University, Fresno
California State University,
Long Beach
California State University,
Los Angeles
California State University,
Northridge
California State University,
Sacramento
California State University,
San Bernardino

California University
of Pennsylvania
Cameron University (OK)
Castleton State College (VT)
Central Connecticut State University
Central Michigan University
Central Missouri State University
Central State University (OK)
Central Washington University
Chadron State College (NE)
Christopher Newport College (VA)
Cleveland State University (OH)
Coastal Carolina College of the
University of South Carolina
Columbus College (GA)
Coppin State College (MD)

D

Delta State University (MS)
Dickinson State University (ND)

E

East Carolina University (NC)
East Stroudsburg University of
Pennsylvania
East Tennessee State University
East Texas State University
Eastern Connecticut State
University
Eastern Illinois University
Eastern Kentucky University
Eastern Michigan University
Eastern Montana College
Eastern New Mexico University
Eastern Washington University
Empire State College (NY)

F

Fort Hays State University (KS)
Fort Lewis College (CO)
Framingham State College (MA)

Note: Two Hundred and fifteen institutions provided data and information. Five institutions provided program descriptions.

Frostburg State University (MD)

G
George Mason University (VA)
Georgia College
Georgia Southern College
Georgia Southwestern College
Georgia State University
Governors State University (IL)
Grand Valley State University (MI)

H
Henderson State University (AR)
Humboldt State University (CA)

I
Idaho State University
Illinois State University
Indiana State University
Indiana University, Northwest
Indiana University of Pennsylvania

J
Jackson State University (MS)
Jacksonville State University(AL)
Johnson State College (VT)

K
Kean College of New Jersey
Keene State College (NH)
Kennesaw College (GA)
Kentucky State University
Kutztown University of Pennsylvania

L
Lake Superior State University (MI)
Lamar University (TX)
Lander College (SC)
Lincoln University of Pennsylvania
Louisiana Tech University
Lyndon State College (VT)

M
Mansfield University of Pennsylvania
Marshall University (WV)

Massachusetts College of Art
Memphis State University (TN)
Mesa State College (CO)
Metropolitan State College (CO)
Middle Tennessee State University
Midwestern State University (TX)
Millersville University
 of Pennsylvania
Missouri Southern State College
Montclair State College (NJ)
Moorhead State University (MN)
Morehead State University (KY)
Murray State University (KY)

N
New Jersey Institute of Technology
New Mexico Highlands University
Nicholls State University (LA)
Norfolk State University (VA)
North Carolina A&T State University
North Carolina School of the Arts
Northeast Louisiana University
Northeast Missouri State University
Northeastern Oklahoma State
 University
Northern Illinois University
Northern Kentucky University
Northern Montana College
Northern State College (SD)
Northwest Missouri State University

P
Pembroke State University (NC)
Penn State Erie, The Behrend
 College
Pennsylvania State University
 at Harrisburg
Pittsburg State University (KS)
Plymouth State College (NH)
Portland State University (OR)

R
Radford University (VA)
Ramapo College of New Jersey
Rhode Island College

S

Salem State College (MA)
Sam Houston State University (TX)
San Diego State University (CA)
San Francisco State University (CA)
Savannah State College (GA)
Shippensburg University
 of Pennsylvania
Slippery Rock University
 of Pennsylvania
Sonoma State University (CA)
Southeast Missouri State University
Southeastern Louisiana University
Southeastern Massachusetts
 University
Southeastern Oklahoma State
 University
Southern Arkansas University
Southern Connecticut State
 University
Southern Illinois University
 at Edwardsville
Southwest Texas State University
St. Cloud State University (MN)
State University College
 at Buffalo (NY)
State University College
 at Cortland (NY)
State University College
 at Fredonia (NY)
State University College
 at Geneseo (NY)
State University College
 at New Paltz (NY)
State University College
 at Potsdam (NY)
State University of New York
 at Purchase
Stephen F. Austin State University
 (TX)

T

Tennessee Technological University
Texas A&I University
Texas Woman's University

Towson State University (MD)
Trenton State College (NJ)
Troy State University
 in Montgomery (AL)

U

University of Akron (OH)
University of Arkansas at Little Rock
University of Arkansas at Monticello
University of Central Arkansas
University of Colorado at Colorado
 Springs
University of Hawaii at Hilo
University of Houston-Downtown
University of Lowell (MA)
University of Maine at Augusta
University of Maine at Presque Isle
University of Maryland, Baltimore
 County
University of Montevallo (AL)
University of Nebraska at Omaha
University of Nevada, Las Vegas
University of North Carolina
 at Asheville
University of North Carolina
 at Charlotte
University of North Carolina
 at Greensboro
University of North Carolina
 at Wilmington
University of North Florida
University of North Texas
University of Northern Iowa
University of Pittsburgh
 at Bradford (PA)
University of Puerto Rico, Bayamon
 Technical University College
University of Puerto Rico, Cayey
 University College
University of Puerto Rico, Humacao
 University College
University of Science and Art
 of Oklahoma
University of South Alabama

University of South Carolina
 at Aiken
University of South Carolina
 at Spartanburg
University of Southern Colorado
University of Southern Maine
University of Southern Mississippi
University of Southwestern
 Louisiana
University of Tennessee
 at Chattanooga
University of Texas at Dallas
University of Texas at Tyler
University of Texas of the Permian
 Basin
University of West Florida
University of Wisconsin-Eau Claire
University of Wisconsin-La Crosse
University of Wisconsin-Oshkosh
University of Wisconsin-Platteville
University of Wisconsin-River Falls
University of Wisconsin-Stevens
 Point
University of Wisconsin-Stout
University of Wisconsin-Whitewater
University of the District
 of Columbia

V
Valdosta State College (GA)

Virginia Commonwealth University

W
Wayne State College (NE)
West Chester University
 of Pennsylvania
West Georgia College
West Texas State University
West Virginia State College
Western Carolina University (NC)
Western Connecticut State
 University
Western Illinois University
Western Kentucky University
Western Michigan University
Western New Mexico University
Western Oregon State College
Western State College of Colorado
Western Washington University
Westfield State College (MA)
Wichita State University (KS)
William Paterson College of New
 Jersey
Winthrop College (SC)

Y
Youngstown State University (OH)

Appendix B

AASCU Committee on the Arts
(1968-1989)

1989
Jane E. Milley, (Chair) Chancellor, North Carolina School of the Arts, University of North Carolina
Sheldon Grebstein (Vice Chair), President, State University of New York at Purchase
Harry Ausprich, President, Bloomsburg University of Pennsylvania
Elsa Berrios de Santos, Chancellor, University of Puerto Rico, Humacao University College
Joseph A. Cox, President, Southern Oregon State College
Marvin Feldman, President, Fashion Institute of Technology (NY)
Lyle A. Gray, President, Castleton State College (VT)
Robert L. Hess, President, City University of New York, Brooklyn College
George W. Johnson, President, George Mason University (VA)
John Keiser, President, Boise State University (ID)
Richard G. Landini, President, Indiana State University
Donald MacPhee, President, State University College at Fredonia (NY)
Richard S. Meyers, President, Western Oregon State College
William F. O'Neil, President, Massachusetts College of Art
W. Ann Reynolds, Chancellor, California State University
Gerald R. Sherratt, President, Southern Utah State College
Winfred L. Thompson, President, University of Central Arkansas
Angelo A. Volpe, President, Tennessee Technological University
Judith A. Sturnick, President, Keene State College (NH)

1988
Jane E. Milley, (Chair) North Carolina School of the Arts, University of North Carolina
Sheldon Grebstein (Vice Chair), State University of New York at Purchase
Harry Ausprich, President, Bloomsburg University of Pennsylvania
Elsa Berrios de Santos, Chancellor, University of Puerto Rico, Humacao University College
Elliott T. Bowers, President, Sam Houston State University (TX)
Irving H. Buchen, President, Westfield State College (MA)
Joseph A. Cox, President, Southern Oregon State College
Lyle A. Gray, President, Castleton State College (VT)
Robert L. Hess, President, City University of New York, Brooklyn College
George W. Johnson, President, George Mason University (VA)
John Keiser, President, Boise State University (ID)
Aubrey K. Lucas, President, University of Southern Mississippi
Donald MacPhee, President, State University College at Fredonia (NY)
Richard S. Meyers, President, Western Oregon State College
William F. O'Neil, President, Massachusetts College of Art
W. Ann Reynolds, Chancellor, California State University
H. Erik Shaar, President, Lake Superior State University (MI)
Gerald R. Sherratt, President, Southern Utah State College

Angelo A. Volpe, President, Tennessee Technological University
Judith A. Sturnick, President, Keene State College (NH)

1987
Jane E. Milley, (Chair) Chancellor, North Carolina School of the Arts,
 University of North Carolina
Sheldon Grebstein (Vice Chair), President, State University College
 at Purchase (NY)
Harry Ausprich, President, Bloomsburg University of Pennsylvania
James W. Cleary, President, California State University, Northridge
James W. Hall, President, Empire State College (NY)
Charles B. House, Jr., President, State University of North Dakota-Valley City
Donald MacPhee, President, State University College at Fredonia
Richard S. Meyers, President, Western Oregon State College
Robert O. Riggs, President, Austin Peay State University (TN)
H. Erik Shaar, President, Lake Superior State College (MI)
Gerald R. Sherratt, President, Southern Utah State College
Edmond L. Volpe, President, City University of New York, College
 of Staten Island
Donald W. Wilson, President, Pittsburg State University (KS)
Judith A. Sturnick, President, University of Maine at Farmington

1986
Donald J. Ayo, (Chair) President, Nicholls State University (LA)
John F. Nolan (Vice Chair), President, Massachusetts College of Art
Harry Ausprich, President, Bloomsburg University of Pennsylvania
Joseph C. Blumel, President, Portland State University (OR)
Calvin W. Burnett, President, Coppin State College (MD)
James W. Cleary, President, California State University, Northridge
Sheldon Grebstein, President, State University College at Purchase (NY)
James W. Hall, President, Empire State College (NY)
Charles B. House, Jr., President, Valley City State College (ND)
John Howell, Chancellor, East Carolina University (NC)
Donald MacPhee, President, State University College at Fredonia
Jane E. Milley, Chancellor, North Carolina School of the Arts, University
 of North Carolina
Robert O. Riggs, President, Austin Peay State University (TN)
Gerald R. Sherratt, President, Southern Utah State College
Albert Somit, President, Southern Illinois University at Carbondale
Donald W. Wilson, President, Pittsburg State University (KS)
Alice Chandler, President, State University College at New Paltz (NY)

1985
Donald J. Ayo, (Chair) President, Nicholls State University (LA)
John F. Nolan (Vice Chair), President, Massachusetts College of Art

Joseph C. Blumel, President, Portland State University (OR)
Calvin W. Burnett, President, Coppin State College (MD)
James W. Cleary, President, California State University, Northridge
Donald N. Dedmon, President, Radford University (VA)
John B. Duff, Chancellor, Board of Regents of Higher Education (MA)
Sheldon Grebstein, President, State University College at Purchase (NY)
James W. Hall, President, Empire State College (NY)
John Howell, Chancellor, East Carolina University (NC)
Edward T. Lewis, President, St. Mary's College of Maryland
Jane Milley, Chancellor, North Carolina School of the Arts, University of
 North Carolina
Donald W. Wilson, President, Pittsburg State University (KS)
C. T. Enus Wright, President, Cheyney University of Pennsylvania
Joseph J. Orze, President, Northwestern State University of Louisiana

1984
Edward M. Collins, (Chair) President, The College of Charleston (SC)
Charles Webb (Vice Chair), President, Eastern Connecticut State University
Donald J. Ayo, President, Nicholls State University (LA)
Calvin W. Burnett, President, Coppin State College (MD)
Donald N. Dedmon, President, Radford University (VA)
John B. Duff, Chancellor, Board of Regents of Higher Education (MA)
John Howell, Chancellor, East Carolina University (NC)
Edward T. Lewis, President, St. Mary's College of Maryland
John F. Nolan, President, Massachusetts College of Art
C. T. Enus Wright, President, Cheyney University (PA)
Aubrey K. Lucas, President, University of Southern Mississippi

1983
Edward M. Collins, (Chair) President, The College of Charleston (SC)
Alice Chandler (Vice Chair), President, State University College
 at New Paltz (NY)
Donald N. Dedmon, President, Radford University (VA)
David W. D. Dickson, President, Montclair State College (NY)
John B. Duff, Chancellor, Board of Regents of Higher Education (MA)
John Howell, Chancellor, East Carolina University (NC)
W. Lloyd Johns, President, California State University, Sacramento
John F. Nolan, President, Massachusetts College of Art
Arthur A. Richards, President, The College of the Virgin Islands
Charles Webb, President, Eastern Connecticut State University
C. T. Enus Wright, President, Cheyney State College (PA)
Joseph J. Orze, President, Northwestern State University of Louisiana

1982
Edward M. Collins, (Chair) President, College of Charleston (SC)

Alice Chandler, (Vice Chair) President, State University College
 at New Paltz (NY)
David W. D. Dickson, President, Montclair State College (NY)
John B. Duff, Chancellor, Board of Regents of Higher Education (MA)
W. Lloyd Johns, President, California State University, Sacramento
Robert Kegerreis, President, Wright State University (OH)
Alfred R. Neumann, Chancellor, University of Houston at Clear Lake City (TX)
John F. Nolan, President, Massachusetts College of Art
John M. Pfau, President, California State College, San Bernardino
Arthur A. Richards, President, College of the Virgin Islands
Charles Webb, President, Eastern Connecticut State College
Gregory Wolfe, President, Florida International University
Joseph J. Orze, President, Worchester State College (MA)

1981
John B. Duff, (Chair) President, University of Lowell (MA)
Edward M. Collins, (Vice Chair) President, The College of Charleston (SC)
Alice Chandler, President, State University College at New Paltz (NY)
David W. D. Dickson, President, Montclair State College (NJ)
Robert Kegerreis, President, Wright State University (OH)
John F. Nolan, President, Massachusetts College of Art
John M. Pfau, President, California State College, San Bernardino
Arthur A. Richards, President, The College of the Virgin Islands
Levi Watkins, President, Alabama State University
Gregory Wolfe, President, Florida International University
Prince B. Woodard, President, Mary Washington College (VA)
Joseph J. Orze, President, Worcester State College (MA)

1980
John B. Duff, (Chair) President, University of Lowell (MA)
Michael Hammond, (Vice Chair), President, State University College
 at Purchase (NY)
Edward M. Collins, President, The College of Charleston (SC)
Gordon Davies, Director, State Council of Higher Education for Virginia
William H. Duncan, President, Millersville State College (PA)
Robert J. Kegerreis, President, Wright State University (OH)
Lionel H. Newsom, President, Central State University (OH)
John F. Nolan, President, Massachusetts College of Art
John M. Pfau, President, California State College, San Bernadino
Levi Watkins, President, Alabama State University
Greg Wolfe, President, Florida International University
Prince B. Woodard, President, Mary Washington College (VA)
Joseph J. Orze, President, Worcester State College (MA)

1979
C. C. Nolen, (Chair) President, North Texas State University
John B. Duff, (Vice Chair) President, University of Lowell (MA)
Dallas K. Beal, President, State University College at Fredonia (NY)
Edward M. Collins, President, The College of Charleston (SC)
Joseph W. Cox, President, Towson State University (MD)
Gordon Davies, Director, State Council of Higher Education for Virginia
Michael Hammond, President, State University College at Purchase (NY)
John F. Nolan, President, Massachusetts College of Art
John M. Pfau, President, California State College, San Bernadino
Roy Troutt, President, University of Science and Art of Oklahoma
Lawrence C. Wanlass, President, College of the Virgin Islands
Prince B. Woodard, President, Mary Washington College (VA)
James Cleary, President, California State University, Northridge

1978
James W. Cleary, (Chair) President, California State University, Northridge
Dallas K. Beal, President, State University College at Fredonia (NY)
Gordon Davies, Director, State Council of Higher Education for Virginia
John B. Duff, President, University of Lowell (MA)
Wendell G. Hardway, President, Fairmont State College (WV)
Bill J. Lillard, President, Central State University (OK)
C. C. Nolen, President, North Texas State University
John F. Nolan, President, Massachusetts College of Art
Roy Troutt, President, University of Science and Art of Oklahoma
Charles B. Vail, President, Winthrop College (SC)
Lawrence C. Wanlass, President, College of the Virgin Islands
Roland Dille, President, Moorhead State University (MN)

1977
James W. Cleary, (Chair) President, California State University, Northridge
Dallas K. Beal, President, State University College at Fredonia (NY)
Joseph L. Bishop, President, Weber State College (UT)
John B. Duff, President, University of Lowell (MA)
Wendell G. Hardway, President, Fairmont State College (WV)
Bill J. Lillard, President, Central State University (OK)
Lionel H. Newsom, President, Central State University (OH)
John F. Nolan, President, Massachusetts College of Art
C. C. Nolen, President, North Texas State University
Robert Suderburg, Chancellor, North Carolina School of the Arts
Roy Troutt, President, University of Science and Art of Oklahoma
Charles B. Vail, President, Winthrop College (SC)
Chester T. McNerney, President, Edinboro State College (PA)

184

1976
John F. Nolan, (Chair) President, Massachusetts College of Art
D. P. Culp, President, East Tennessee State University
Wendell G. Hardway, President, Fairmont State College (WV)
William E. Highsmith, Chancellor, University of North Carolina at Asheville
Charles P. Hogarth, President, Mississippi University for Women
Kermit A. Johnson, President, University of Montevallo (AL)
Bill J. Lillard, President, Central State University (OK)
C. C. Nolen, President, North Texas State University
John S. Rendleman, President, Southern Illinois University at Edwardsville
Wendell P. Russell, President, Federal City College (DC)
Charles B. Vail, President, Winthrop College (SC)
Marjorie Downing Wagner, President, California State College, Sonoma
Chester T. McNerney, President, Edinboro State College, Pennsylvania

1975
John F. Nolan, (Chair) President, Massachusetts College of Art
D. P. Culp, President, East Tennessee State University
James Gemmell, President, Clarion State College (PA)
Charles P. Hogarth, President, Mississippi University for Women
Kermit A. Johnson, President, University of Montevallo (AL)
Abbott Kaplan, President, State University College, Purchase (NY)
C. C. Nolen, President, North Texas State University
Benjamin L. Perry, Jr., President, Florida A&M University
John S. Rendleman, President, Southern Illinois University at Edwardsville
Wendell P. Russell, President, Federal City College (DC)
Charles B. Vail, President, Winthrop College (SC)
Marjorie Downing Wagner, President, California State College, Sonoma
Chester T. McNerney, President, Edinboro State College (PA)

1974
Henry L. Ashmore, (Chair) President, Armstrong State College (GA)
James Gemmell, President, Clarion State College (PA)
Charles P. Hogarth, President, Mississippi State College for Women
Abbott Kaplan, President, State University of New York, College at Purchase
John F. Nolan, President, Massachusetts College of Art
Benjamin L. Perry, Jr., President, Florida A & M University
Howard C. Rose, President, Valley City State College (ND)
Charles Vail, President, Winthrop College (SC)
Donald E. Walker, President, Southeastern Massachusetts University
Milton B. Byrd, President, Chicago State University (IL)

1973
Henry L. Ashmore, (Chair) President, Armstrong State College (GA)
James Gemmell, President, Clarion State College (PA)

Charles P. Hogarth, President, Mississippi State College for Women
Abbott Kaplan, President, State University of New York, College at Purchase
James F. Nickerson, President, Mankato State College (MN)
John F. Nolan, President, Massachusetts College of Art
Benjamin L. Perry, Jr., President, Florida A&M University
Howard C. Rose, President, Valley City State College (ND)
Roman J. Zorn, President, University of Nevada at Las Vegas
Milton B. Byrd, President, Chicago State University (IL)

1972
Henry L. Ashmore, (Chair) President, Armstrong State College (GA)
Abbott Kaplan, President, State University College at Purchase (NY)
James F. Nickerson, President, Mankato State College (MN)
Charles P. Hogarth, President, Mississippi State College for Women
Howard C. Rose, President, Valley City State College (ND)
Roman J. Zorn, President, University of Nevada at Las Vegas
John F. Nolan, President, Massachusetts College of Art
Benjamin L. Perry, Jr., President, Florida A&M University
James Gemmell, President, Clarion State College (PA)
Charles F. Bolen, (Consultant) Dean, College of Fine Arts,
 Illinois State University
Darrell Holmes, President, East Stroudsburg State College (PA)

1971
Abbott Kaplan, (Chair) President, State University of New York,
 College at Purchase
Henry L. Ashmore, President, Armstrong State College (GA)
James Gemmell, President, Clarion State College (PA)
Leonard C. Haas, President, Wisconsin State University at Eau Claire
Charles P. Hogarth, President, Mississippi State College for Women
John F. Nolan, President, Massachusetts College of Art
Benjamin L. Perry, Jr., President, Florida A&M University
Howard C. Rose, President, Valley City State College (ND)
Roman J. Zorn, President, University of Nevada at Las Vegas
Charles W. Bolen, (Consultant) Dean of Fine Arts, Illinois State University
James F. Nickerson, President, Mankato State College (MN)

1970
Abbott Kaplan, (Chair) President, State University College at Purchase (NY)
Henry L. Ashmore, President, Armstrong State College (GA)
M. N. Freeman, President, Black Hills State College (SD)
James Gemmell, President, Clarion State College (PA)
John A. Guinn, President, Texas Woman's University
J. W. Maucker, President, University of Northern Iowa
John F. Nolan, President, Massachusetts College of Art

Benjamin L. Perry, President, Florida A&M University
Grellett C. Simpson, Chancellor, Mary Washington College (VA)
James F. Nickerson, President, Mankato State College (MN)

1969
Abbott Kaplan, (Chair) President, State University College at Purchase (NY)
Henry L. Ashmore, President, Armstrong State College (GA)
Robert L. Bertolli, President, Massachusetts College of Art
Herman R. Branson, President, Central State University (OH)
Alexander Capurso, President, Stanislaus State College (CA)
M. N. Freeman, President, Black Hills State College (SD)
John A. Guinn, President, Texas Woman's University
James F. Nickerson, President, Mankato State College (MN)

1968
James F. Nickerson, (Chair) President, Mankato State College (MN)
Alexander Capurso, President, Stanislaus State College (CA)
W. Everett Derryberry, President, Tennessee Technological University

ãª ãª ãª

In addition to members of the Committee on the Arts, Nolan Ellison, President, Cuyahoga Community College (OH) and James Hefner, President, Jackson State University (MS) assisted with this study.